Drawing Traditional Buildings

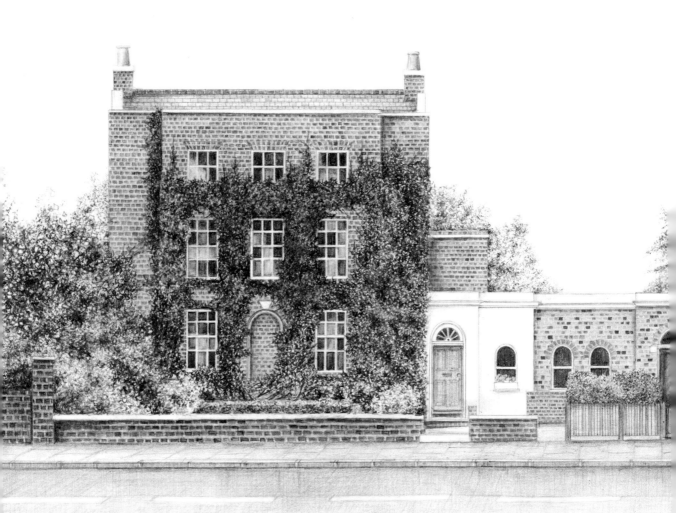

Drawing
Traditional
Buildings

RICHARD S. TAYLOR
SGA MSAI

ROBERT HALE · LONDON

© *Richard S. Taylor 1987*
First published in Great Britain 1987

Robert Hale Limited
Clerkenwell House
Clerkenwell Green
London EC1R OHT

British Library Cataloguing in Publication Data
Taylor, Richard S.
Drawing traditional buildings.
1. Vernacular architecture in art
2. Vernacular architecture – England
3. Drawing – Technique
I. Title
743'.84 NC825.B8
ISBN 0-7090-2969-1

Design by Joanna Restall

Photoset in Sabon by
Rowland Phototypesetting Limited
Bury St Edmunds, Suffolk
Printed and bound in Great Britain by
Butler & Tanner Limited, Frome, Somerset

Contents

Illustrations

Diagrams

In the pastel skies of sunset I have wandered,
with my eyes, and ears, and heart strained to
the full.

D. Leitch

Acknowledgements

I wish to gratefully acknowledge the technical assistance of Charles Buchanan for historical research, and Terry Booker for clerical skills throughout the compilation of this book.

Also thanks are due to my family for their constant care and support, and to Debbie Munday for assistance beyond the call of duty.

Foreword

Throughout my own career as an artist/ architectural illustrator I have been greatly inspired by the buildings of rural Britain, for three possible reasons. Firstly, I must confess to a level of romanticism. The peace and tranquillity to be found in a village whilst sitting amid its very fabric is not only therapeutic but also nostalgic. The rustic red brick houses with their tumbledown porches are reminiscent of scenes from Laurie Lee's *Cider with Rosie* or Flora Thompson's *Lark Rise to Candleford*.

The thatched cottages lined along the winding roads in many villages could well harbour memories of hundreds of years, silently bearing tales of many generations of country life. But the towns have their magic also. The buildings there can often conjure up images of Victorian coaches rattling across the cobblestones, or even of the late-medieval markets, with traders hawking their wares through the narrow streets. Everywhere the past can live through buildings.

Here lies my second interest. Whilst it is easy to revel in romantic nostalgia, a much harsher lesson can be learned through simply looking at buildings. The socio-economic history of a nation can be observed on the streets of towns and villages. A country's periods of growth and decline are reflected in the buildings of the day. Wars, royal visits, and plague are all embodied within the buildings of the town or village in which they occurred, and those buildings can tell many tales of triumph or disaster for the people of the district. I find this area of enquiry absorbing, and for this reason I have dwelt on the history of certain types of buildings and the social implications of their very existence throughout this book.

Thirdly must come the obvious joy of drawing in the environment created by the builders of England throughout its long history. Drawing can be relaxing on a Sunday morning in late spring when the parish church bells are chiming in the far distance. It can also be tense, demanding and all-absorbing. (I have often found myself working late into the evening on a rural location, barely noticing that the shadows have all changed direction since I started the com-

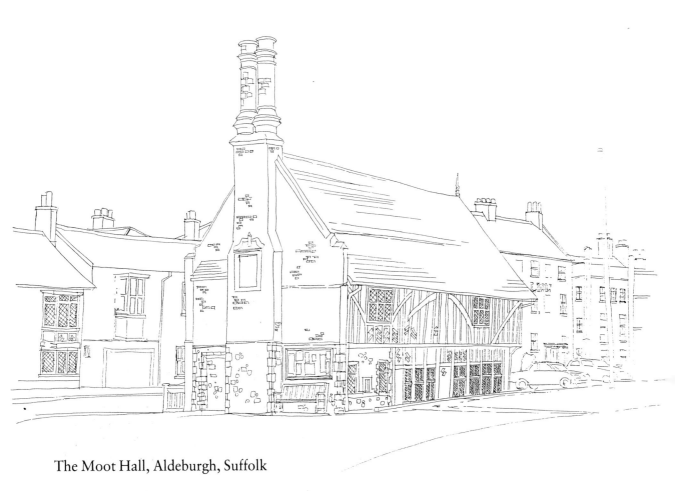

The Moot Hall, Aldeburgh, Suffolk

position, and the evening light fading.) It can be rewarding, satisfying, irritating and occasionally frustrating. But whatever else it is, it must be fun. Enjoy it always.

I am reluctant to use the word 'architecture' here when discussing buildings. 'Architecture' is often associated with mathematical accuracy, design concepts and the physical sciences and is, in fact, seen as an academic study. This book is about neither mathematical accuracy nor technical representations but invokes the pure joy and excitement of drawing the buildings

you can see everywhere and every day.

Contrary to popular belief, buildings are particularly simple to draw, due to their basic geometric 'box' shape. Looking back to the turn of the century and the prominent Impressionist group of artists that emerged in France, one particular artist, Cézanne, expounded his theory that all objects could be represented using three fundamental geometric shapes – the cube, sphere and cone. From this point onwards, as artists realized the truth of this, the whole concept of art-teaching changed. The basic shapes were practised and drawn, allowing the ob-

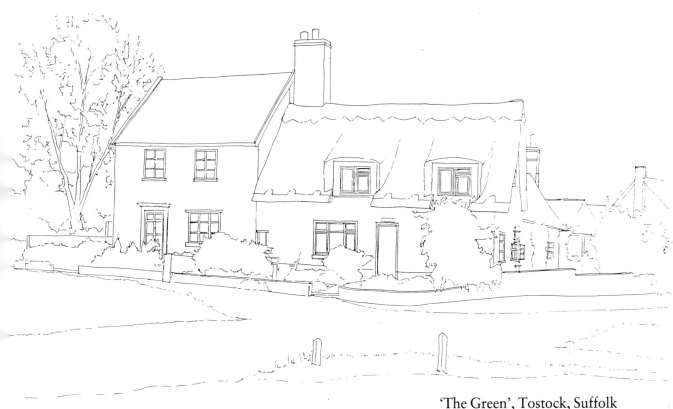

'The Green', Tostock, Suffolk

jects found in everyday life to fit into these geometric forms. Houses and buildings are particularly suited to this style of drawing construction.

This is a method or technique that I advocate throughout this book and which I have used in many of the courses on which I have taught. It is based upon the fundamental idea that all buildings will fit into a basic box shape. Understanding this will, in time, change your whole perception of the world you live in, as you will see rows of houses and buildings in a very different way. If you can start to look at buildings and their facets and try to visualize them as simple geometric shapes, the whole business of recording them on paper becomes considerably easier. This is not just about a way of drawing but about a way of seeing. Perception is the artist's greatest asset and can be learned and developed – not in weeks but over a long period.

Whilst this method of perception is fundamental to drawing construction, it must be seen as a set of guidelines only. Always be prepared for the one odd building that will defy all construction rules, as country buildings do come in many shapes and forms.

Regional variations exist, but they are more frequently in structure and fabric than in basic shape. The stone cottages of Cumbria will frequently be of a similar appearance but built of stone totally different to the fabric of village cottages of Norfolk. The churches will also have fundamental similarities in structure, yet essential differences in fabric. The main point is that the wealth of regional variations rarely affects the basic starting point for the artist. It will have serious implications for the completed drawing or composition, but most drawings will start off in the same way and with the same methods of composition.

This book is not about hard-and-fast rules either. It is about perception, guidelines and providing information for anyone wishing to discover or investigate further the joy of drawing traditional buildings. It is also about what to look for before you start to draw. Preparation is essential – not just by having the correct equipment ready and at hand but also by knowing exactly what to look for before you begin. By doing this you will avoid many pitfalls.

These points I have learned not only as a practising artist but also as a practising teacher. Having worked in most areas of art education during the past ten years, I have learned much about teaching myself – most of my teaching nowadays is with adults returning to 'art' after years away from formal study. The guidelines, methods and techniques I employ on all courses are contained within this book in as precise and detailed manner as is possible. They are based on the need for positive instruction tempered with encouragement for personal enquiry which emerges time after time as requirements for students of all ages.

This book is also about drawing in any medium, although the two direct areas examined are pencil and pen. Where differences of technique become obvious, they are examined, highlighted and explained. But generally the basic principles are the same. Here, perhaps, lies the key to the whole book. Whilst numerous exciting and stimulating variations of both style and technique of drawing and differences within your subjects exist, they all have a very basic and simple starting-point.

So before you start, one final thought. You *can* learn to draw. I know, as I have taught many people. You will rarely discover hidden talents overnight or master new techniques and skills the very first time you try them. But with patience and enthusiasm you will not only learn to draw but also discover the thrill and pleasure that can be gained from sketching and drawing the beauty of the nation's towns and villages.

Many of the illustrations in this book are of two places, Enfield, in Middlesex, and Woolpit, in Suffolk. Both embody the architectural styles and history I enjoy drawing so much and are of some personal relevance.

Enfield, once a Royal Borough, is full of Georgian houses, once set in countryside, now very much part of Greater London. Past these magnificent buildings in Enfield Town I went daily to school, and I soon grew to love the calm dignity that rests upon the well-preserved side streets. Even today, having made my home in East Anglia, I still visit Enfield frequently to relax and sketch

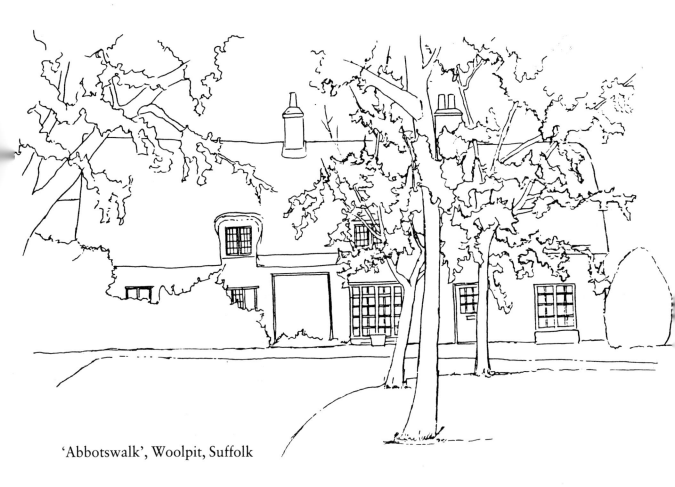

'Abbotswalk', Woolpit, Suffolk

amid the gracious Georgian cottages, and in the grounds of grander buildings that are now so much a part of North London.

In 1973 I left Enfield to move to East Anglia, and have stayed there ever since. Here I found a marked contrast in the built environment in which I lived and worked each day. Woolpit, a tiny, near-medieval village nestling quietly in the open farmland of Suffolk, is virtually made up of old leaning timber-framed cottages. It contains neither the grandeur nor the elegance of Enfield Town but maintains an unspoilt rural charm throughout the seasons and is small enough to get to know thoroughly. I set out a couple of years ago to record all the buildings in Woolpit for my own personal pleasure, and have used some of these as examples in this book. The historic and picturesque qualities have endeared the village greatly to me, as have its inhabitants, many of whom have become good friends through my work.

But wherever you live and wherever you travel, every town or village has something of interest to the artist. Not all villages have such a wealth of aesthetically pleasing buildings as Woolpit, or the number of elegant terraces in Enfield, but they will all have something to offer. The centres of towns

and villages will generally offer the most historically important buildings, as the settlement will have grown up around them. But never exclude the outskirts from your exploration. Even the odd or unusual window, or a particularly decorative chimney-stack, can provide a valuable and interesting subject for drawing or sketching. Wherever you go, something will be worth drawing!

Skies play an important part in determining the 'mood' or atmosphere of the day. It will soon become obvious when looking through the illustrations in this book that I rarely draw any type of cloud structure into my pictures. The reasons for this are as follows. Firstly, over-active skies can easily dominate a picture, making the viewer feel uneasy about exactly what they are looking at – a set of buildings perhaps, or a heavy storm-laden sky. Secondly, skies can very easily become 'messy' or 'smudged' as a result of over working. However, should you feel that an element of background sky would enhance your composition then this is how to go about it.

Firstly, sketch in the cloud shapes as lightly as possible so that they are only visible if you know where to look. This is easy when working in pencil, but much care must be exercised if working in pen – a faint sketchy line is all that you can afford to use as clouds do not in fact have outlines.

Having established the cloud shapes, the next stage is to fill in the sky behind. Again, with pencil the technique is easier. Using a 4B pencil lightly shade diagonally across the sky using the edge of the pencil only. The tone should be continuous, and blend softly as you work across the composition. Never use the tip of the pencil as this will result in a series of specific lines which will ruin the effect. At this point some artists cannot resist the temptation to 'smudge' the shading to soften the overall image. All this does in fact is to leave a whole series of smears, often in the form of your finger prints across your picture. So try to resist. Work only with your pencil creating the smoothness by constantly, but lightly, working across the sky with the edge of a soft pencil.

When drawing with pen the same principles apply but the technique is different. Again, establish the cloud shapes and shade behind them with a series of fine diagonal lines, only now you do not have the luxury of being able to re-work the sky to attain a level of softness. Each pen line must be fine, light and rapid, resulting in a sketchy, or even 'scratchy' effect. Broken lines are useful, as continuous lines will be thicker and will certainly attract attention where it is really not required.

The most important message here is if in doubt leave the sky alone – at least until you have had a few practice runs. You will not do too much harm if you include a sky in some of your two minute sketches, but do not attempt it on your more elaborate work until you have greater confidence.

All objects can be represented using three fundamental geometric shapes: the cube, sphere and cone.

Remember buildings are relatively simple to draw, due to their basic geometric 'box' shape.

Look at buildings as simple, geometric shapes – then you will find them much easier to draw.

1. A Brief History of England's Rural Buildings

When the Roman legions landed on the shores of Celtic Britain, they found, contrary to Roman propaganda, a highly structured society bound together by strong tribal loyalties, centred around laws, religion and the family. The Celts were an artistic, if somewhat warlike people who wrought magnificent jewellery and weapons of destruction. Quite often the Celtic community was situated in a man-made hill fortress, as at Maiden Castle in Dorset and South Cadbury in Somerset. Their dwellings were made out of a mixture of wood, straw and mud.

The Roman occupation of Britain soon brought about the end of the Celtic way of life, especially in the south of the country. Small, independent tribal communities were gradually replaced by a highly organized central power. The Romans believed that urbanization could de-tribalize the Celts and turn them into model Roman citizens. To a large extent they were right, for when the imperial legions withdrew from the country in the late fourth century, the natives found themselves helpless. They had long forgotten the tribal ways of their forefathers and yet were incapable of maintaining the Roman system of government. Towns began to fall into disuse, and their populations once more took to the hills and countryside. Celtic hill-forts, long since abandoned, were revived.

The concept of the modern English village finds its origins in the 'Dark Ages' of the fifth to tenth centuries. The Anglo-Saxons virtually started from scratch, except for a few isolated pockets in the west of the country. They cleared great areas of dense, damp forests consisting of oak, ash and beech, although there is some evidence to suggest that Roman villas and their estates were revived by the developing aristocracy. The situation of villages was dictated by fertility of the soil, as many areas – such as the high mist-wrapped moorlands of the north and drowned marshes of the south and west – proved difficult to cultivate.

The Anglo-Saxons lacked the organized planning of the Romans. In general, their settlements consisted of a handful of homesteads displayed in *ad hoc* fashion. The

economy of the settlements was undoubtedly agricultural. The building materials were timber and thatch supplemented by wattle and daub. The dwellings were rectangular, with gabled roofs. The villages themselves tended to be of an enclosed or linear nature. (Enclosed villages consisted of a central green usually accompanied by a pond; linear villages simply lined the through road.) In spite of their cluttered appearance, it is remarkable to note the almost uniform distance between them, still demonstrated in rural areas such as Norfolk and Suffolk.

The majority of villages founded by the Anglo-Saxons, especially during the latter part of the Dark Ages, are still in existence. This is probably due to the Christianization of the country: a parish church gave the village a focal point. Also, the character of the 'open field' system of farming made it impracticable for the settlement to move around: every patriarch tilled his own smallholding, working in harmony with his neighbours to the benefit of the community at large.

The Norman Conquest of England brought in a colder, harsher regime. The king decreed that all the land belonged to him and that great nobles would have to 'let' their estates from him in return for military services. This act not only robbed the English peasant of his smallholding: it robbed him of his personal freedom.

The medieval village rarely boasted a population of more than a hundred people. The only substantial buildings were the manor house, church and mill. As in Anglo-Saxon times, the villages were strung out willy-nilly. The structure of a peasant dwelling depended on what building-materials were readily at hand. In lowland England, there appear to have been three distinct types of peasant dwellings.

The 'cot' was a one-roomed homestead usually no more than 5 metres by 3.5 metres (16 by 11½ feet) and was inhabited by the 'cottar' (or 'bordar') and his family. He was at the bottom of the social scale and owned no land of his own.

The 'longhouse', as its name suggests, was a more substantial dwelling than the cot. It could be anything between 15 and 30 metres (49 and 98 feet) in length, large enough to support the prosperous peasant's family in the upper end of the cottage, where the hearth would be situated, whilst the animals would be stalled at the lower end.

By far the most superior of all peasant dwellings were the farmhouses, inhabited by the yeoman farmers who came to prosperity in the later medieval period. The farmhouses had a barn (or 'byrne') situated at right angles to the main building and were the forerunners of the modern farm dwellings.

In lowland England, during the early medieval period, dwellings were built out of turf, clay or timber and had to be rebuilt or replaced every twenty years or so. Recent archaeological excavations, however, have revealed that dwellings of the later medieval period were constructed of stone, except in East Anglia, where stone was scarcer. Here, builders used flint, which could be found locally in large quantities.

The medieval peasant cottage was usually insulated with wattle and daub, which were used as infilling between the timber uprights. The large number of metal keys,

hinges and latches found at medieval sites suggests that the dwellings had solid doors. But they had no glass windows: during the day, wooden shutters would be opened to let in the light, and they would be closed again when darkness descended. The floors consisted of stone, cobbles or clay. It seems probable that the roofs of most of these dwellings consisted of light-weight timbers laid on ridge poles and covered with thatch – although archaeology has in no way confirmed this assumption. In the reed-growing area of East Anglia the quality of the thatch was much higher than in other parts of the country. Dwellings which boasted cruck blades (timber joists which rose from the walls and which gave solid support to the roofs) have survived in great numbers – about 2,000 in the north and west.

Life in a medieval village was long depicted as one of hardship and despair: large families living in filth and squalor, with the shadow of death ever lurking. We now have a more balanced view of medieval life. For example, there is strong evidence to suggest that the medieval housewife was exceedingly houseproud, constantly sweeping her earthen or stone floor.

The prosperity of the English village from the Conquest until the Industrial Revolution fluctuated dramatically. It appears that the years between 1066 and 1200 were a boom period, the very favourable climatic conditions helping the cottager produce plentiful harvests. The fourteenth century, however, was particularly catastrophic. The climate changed, causing widespread famine: northern villages suffered from the ravages of the Anglo-Scottish wars and, worst of all, the Black Death wiped out a high percentage of the population. During this century many villages were deserted, never to be re-inhabited. Today they are lost beneath generations of ploughed fields.

The Tudor period saw a notable revival, especially in East Anglia, which became Europe's chief exporter of wool. Yet, as the seventeenth and eighteenth centuries passed, the fortunes of the English village, once the heartbeat of the nation, began to wane forever. Peasant smallholdings made way for the new gentleman farmer's large estate. The whole structure of society changed. The once densely populated South-East became economically less important as many of its inhabitants moved northwards to the industrial factories and developing towns, which in time became the new pulse of the country. These people needed to be rehoused near to their new jobs, and so the emphasis on domestic building shifted to these rapidly-developing areas.

Most villages of today bear little resemblance to their pre-Industrial Revolution counterparts. Yet, whatever their structure, be they Cotswold stone, East Anglian timber or Yorkshire limestone, they are our heritage and a living link with the past. Let us hope that the English village will be preserved and revered long into the 'high tec' future, so that future generations will be able to appreciate and be reminded of the inspiration and aspirations of their forefathers.

2. Equipment

I've often heard it said that 'a bad workman blames his tools', but I've rarely heard that good craftspeople praise theirs. The tools of any trade will always aid the success and consequent personal satisfaction of the craftsperson, either professional or amateur.

Fortunately, equipment for drawing is simple and not very expensive: even the best is affordable (albeit a luxury); at the other end of the scale few people could say that they don't own a pencil.

So the initial intimidation of wondering 'What do I need to start?' is easily dismissed. You start with a pencil and a sheet of paper and progress according to your needs from there on.

Like most artists, I have two sets of equipment which, whilst duplicating in many instances, serve different purposes. Sitting at a drawing-board within the warm confines of my studio is very different from sitting on a draughty street corner with an irritating breeze attempting to blow the paper away with every gust. Flies, rain and passing seagulls are renowned for the lack of consideration they afford to the outdoor artist.

Different approaches are thus required to enable both types of drawing to be undertaken properly and to your own satisfaction. Your stock of equipment will soon accumulate with experience and will develop to meet your requirements at whatever level you wish to work. This, however, is the equipment that I generally use.

PAPER

For studio work I keep a good stock of white cartridge paper. Whilst 120 gram paper is quite adequate, a firmer 140 gram paper will give a better surface to work on and will not come to so much harm should you need to move it around the house – it will not fold or crease so easily. Cheaper cartridge paper is fine for planning or for sketches that will probably end up in the bin, but it is not an investment. If exposed to normal daylight over a period of months, this paper will gradually yellow or develop a similarly unpleasant tint. The cartridge paper I use for most of my pencil drawings is slightly tex-

tured and is well suited to use with a good graphite pencil. Size is, of course, at your own discretion. I rarely work on anything under A4, as I find I cannot fit the scale of brickwork onto anything smaller. This also allows a small border to be drawn around your work – an aid to presentation that will be examined later.

For pen drawing in the studio, I keep a stock of ivory board – or 'illustration boards' as they are often known. Incidentally, a very smooth (although thinner) type of board which is equally suitable (and considerably cheaper) for line drawing can often be obtained from a friendly printer. These silk-textured boards are used purely for line work, allowing an uninterrupted flow of ink, reducing the possibility of bleed from fibre-tip pens. It is important to remember that these will not take a wash.

All these articles are used for finished studio and presentation work – the result of many hours spent sketching in cold streets or on idyllic village greens amid the rolling English countryside, basking in an autumnal sunset. It is, after all, the outdoor environment from which we draw our information and inspiration.

For sketching and outdoor work I use ringbound pads for both pen and pencil. Both smooth and textured cartridge pads are available in an assortment of sizes and at an assortment of prices. I prefer the ringbound pads for the simple reason that I like to keep an autobiographical record of the places I visit and sketch at. Ringbinding allows me to return from a trip with this record intact, not having had to tear each page from a block before progressing to the next sheet, only to watch my last few hours of work disappearing rapidly along the village high street with the first gust of wind.

IMPLEMENTS

An assortment of 'mark-making' utensils exist, many of which are not totally suited to recording architectural facets. Charcoal and Conté pencils are perfect for creating a brief impression or capturing the atmosphere of a large area where detail is suggested rather than drawn. This is, however, a highly developed skill involving many hours of practise. Graphite pencils are much more suited to drawing all varieties of buildings. They come in many forms and sizes and do vary considerably in quality. My choice for all pencil work is the full Rexel Cumberland Graphite range from H through to 6B, including all grades in between. Whilst the H-grade pencils are rarely used in an 'artistic' capacity, I do use them for lightly drawing in the brick courses. A 2B is useful for the bricks, a 4B for windows and the 6B for the darkest shadows in nooks and crannies.

The older 'dip' pens are still fun to draw with, but modern advances have resulted in their becoming virtually redundant. Nowadays, pens can be divided into two categories: the ink pens such as the Rotring 'Isograph' and the many other popular brands, and the rapidly developing range of fibre-tip pens. The ink pens have the advantage of interchangeable nibs which at present come in much smaller sizes than the fibre pens. The Indian ink does produce a deeper black, is permanent and is kept securely inside the pen with no risk of spillage. It also dries in the nibs if left unused for a period of time, occasionally blocking them, often permanently. This is where the

fibre pens score points. They are considerably cheaper, less messy, more reliable and ultimately disposable – you will appreciate this the first time you drop your Isograph on its nib! Both have their advantages and disadvantages.

I have a range of nibs (0.25, 0.35 and 0.50) for my ink pens that I use for all studio work. I can attain the finest lines to satisfy architects, yet draw a broad line for reduction by a printer. The Indian ink is also perfect for reproduction. These pens are, however, expensive and stay within the boundaries of the studio. I take a range of fibre pens out sketching. The Berol Fineline is a good general sketching pen, whilst the Edding Profipen comes in a range of finer sizes for more accurate work. The fibre pens you will inevitably lose to the odd passing motorist or rogue drain should not upset you too much – they are cheap and easily replaceable.

Add the small essentials: a good pencil-sharpener (the cheaper versions will only break the leads of softer pencils with irritating regularity) and a putty rubber which will not leave a smear on your paper. I have two sets of these, one for the studio, the other kept in my sketching bag.

Whilst I have a drawing-board in my studio, I have never found any of the various easels/donkeys, drawing-boxes etc of much value when it comes to outdoor drawing. A folding chair and a good drawing-pad with a hard cardboard backing have served me and many other artists well for many years.

Art shops are often stacked high with many of the same type of drawing-pads, blocks, pencils, pens, rubbers and easels – the many brand names may be confusing. The few brand names I have mentioned are, in my opinion, the best. This in no way dismisses the many quality makers – it is purely my own preference. Do, however, experiment. Your personal equipment will develop only through the discovery of your own preferences.

You will need:

140 gram white cartridge paper and ivory boards for studio work

Ringbound pads for outdoor work

Graphite pencils – for all work

Ink pens with interchangeable nibs for studio work

Fibre-tip pens for outdoor work

Pencil sharpener

Putty rubber

3. Making a Start: Basic Perspective and Composition

All drawings have to start somewhere, and in the case of buildings, streets or alleys the key lies in establishing the point to which the lines of the rooftops seem to converge (see **Diagram 1**). This is the first venture into perspective – a much revered term that can be unnecessarily complicated.

PERSPECTIVE

Establishing the correct perspective is the first step to take when drawing buildings and will 'make or break' your picture. It is essential, therefore, to get it right. Although this is a skill that will not develop overnight and will need much practising, there is no need to be intimidated by it. The techniques can be considerably simplified.

The whole concept of perspective is based upon the optical illusion which suggests that parallel lines converge as they go away from the viewer, as in the case of telegraph poles and wires following a straight road across a flat desert (see **Diagram 2**). The resulting impression is of similar objects gradually becoming smaller as you look along the straight road, with a series of imaginary lines running along the tops of these objects (in the case of this book, the rooftops would be the objects that will concern us).

The near-geometric structure of many buildings lends itself to a simple method of perspective construction. This system involves establishing the basic box shape into which the vast majority of buildings will fit (with a little modification here and there). These are the basic stages of construction:

Diagram 3a: Establish the fundamental box shape of the two walls facing you (it is not possible for more than two walls to be visible to you at any time). Try to see this shape as a box made up of the walls and ignore the roof for this section. **Diagram 3b**: Now add the roof, forming the triangular end with the apex being central to its supporting wall. The top line of the roof will converge slightly towards the base line of the roof – try not to over-exaggerate the degree of convergence as this will distort the perspective. The two side lines joining the base line to the top line (the edges of the roof) must be parallel. **Diagram 3c**: Next, observing the same constructional rules,

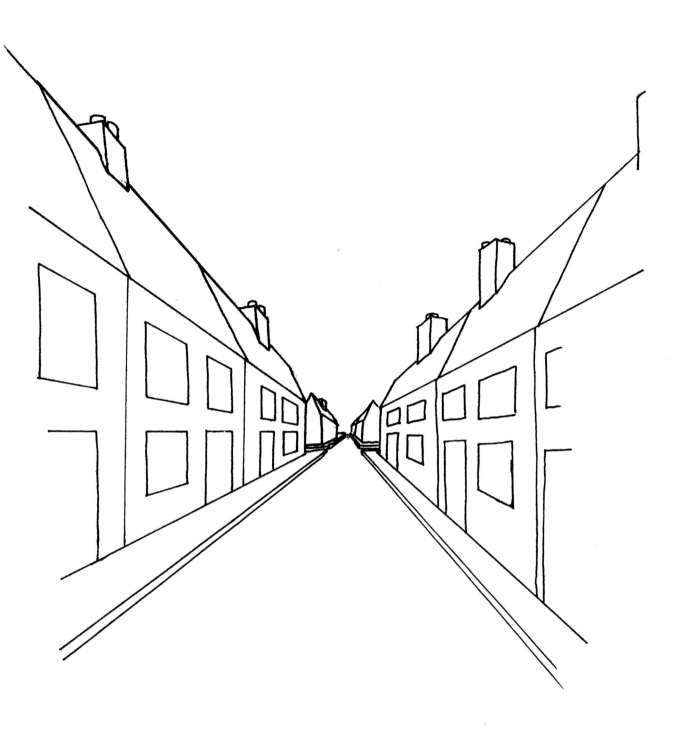

Diagram 1
Converging perspective lines in a linear street

26

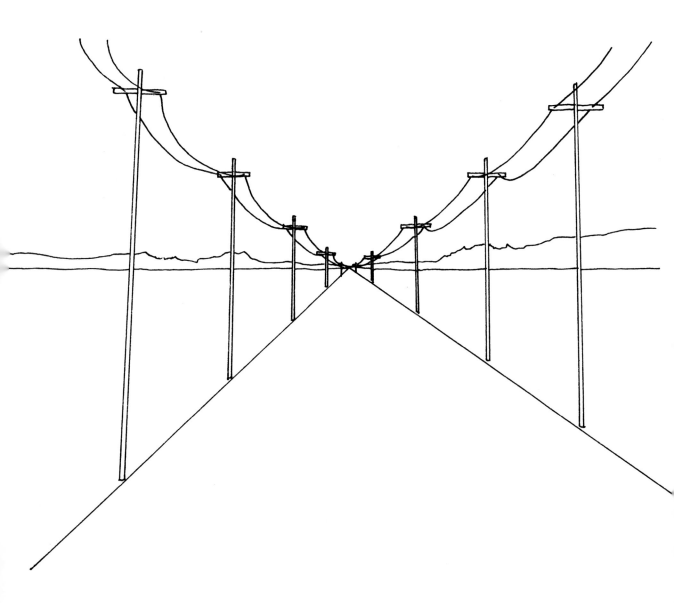

Diagram 2
The basic perspective principle

27

Diagram 3a
Establish the basic box shape

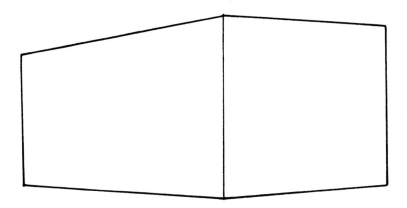

b
Add the roof

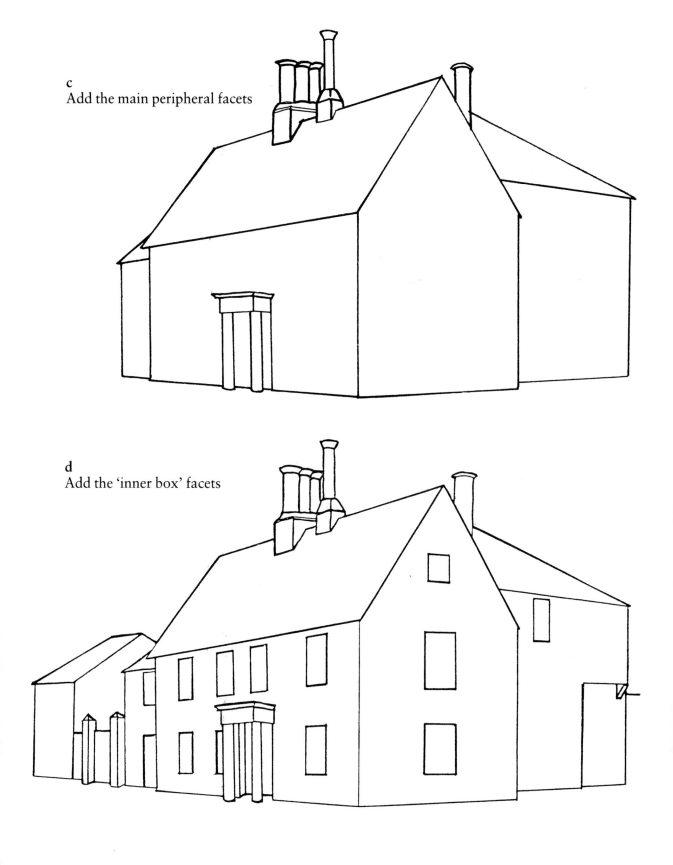

c
Add the main peripheral facets

d
Add the 'inner box' facets

add on any peripheral sections that are integral to the structure of the building – chimney stacks etc. (These will all be dealt with in much more depth later, on p. 81.) **Diagram 3d**: Finally, add the windows, still observing the perspective rules whereby each window will appear to become proportionally smaller at the furthest end of the building, along with the walls and roof.

This is the most basic of drawing methods. Naturally, many odd bits of architecture will defy all rules of construction, from both the artist's and the builder's viewpoint. But you will develop an 'eye' for these sections as you get out onto the streets to practise. Some of the rule-breakers can, however, be contained within a loose set of guidelines.

One very familiar method of building construction found in both town and country is that known as 'jettying', established initially during the seventeenth century and used for many years. This involved the building of a basic box framework (timber frame), then adding a second floor that extended beyond the area of the lower floor, leaving overlapping sections (see **Illustration B**). One of the most feasible reasons given for this is that groundspace was limited and expensive in medieval towns, and that by 'jettying' it was easy to create a larger floor space on the second floor than one had on the ground, thus avoiding having to pay higher taxes. In several towns you may see three or four storeys of jettying, creating some fascinating buildings. Apart from their aesthetic qualities, these buildings can be ideal for practising perspective.

Diagram 4a: Start off, as usual, with the basic rectangular box construction in order to establish the length and scale, then add the appropriate top floor section, still in box form. **Diagram 4b**: Add the main roof(s) and establish any other box sections – in this case the porch – that require roofs, again being careful not to over-exaggerate the degree of convergence on the top and bottom perspective lines. Also in this particular case it is important to note the overlap of the roof. **Diagram 4c**: Next, add on the peripheral parts that are essential to the actual building. **Diagram 4d**: Finish off by adding the windows, foliage and doorways.

As always with white- or light-walled buildings, the roof becomes a visually exaggerated feature. As the old tiled roof projects beyond the limits of the walls, some very strong shading is called for under the decorated eaves at the front, and on the plain side wall, adding to the all-important three-dimensional effect.

A few last points are worth noting about jettied buildings. They will at times lend themselves to perfect 'box construction' and on other occasions defy all the laws of perspective and even gravity. Many timber-framed buildings lean at an alarming angle or are twisted and distorted to a seemingly frightening degree. The truth is, however, that they will probably outlast many of the small houses built today and are perfectly safe. In fact, I would strongly advise that buildings with particularly marked slopes be avoided by beginners in their early stages. Have a go at drawing some more 'regular' buildings with only slight twists and slopes first. As your confidence develops, your 'eye' for the unusual will develop also, allowing you to record more extreme domestic distortions with confidence and accuracy.

Diagram 4a
Stage A – Basic 'jettying' box structure

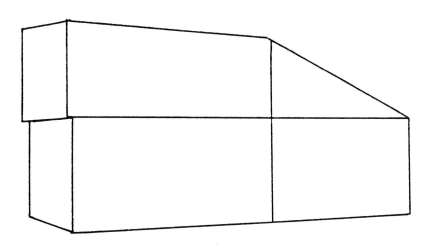

b
Stage B – Add roofs

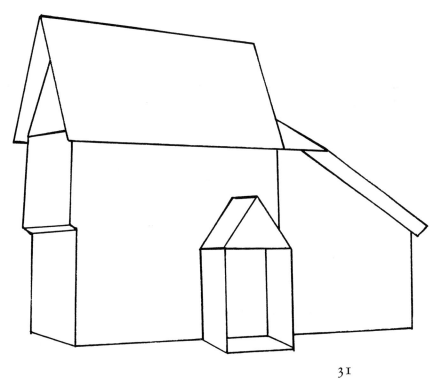

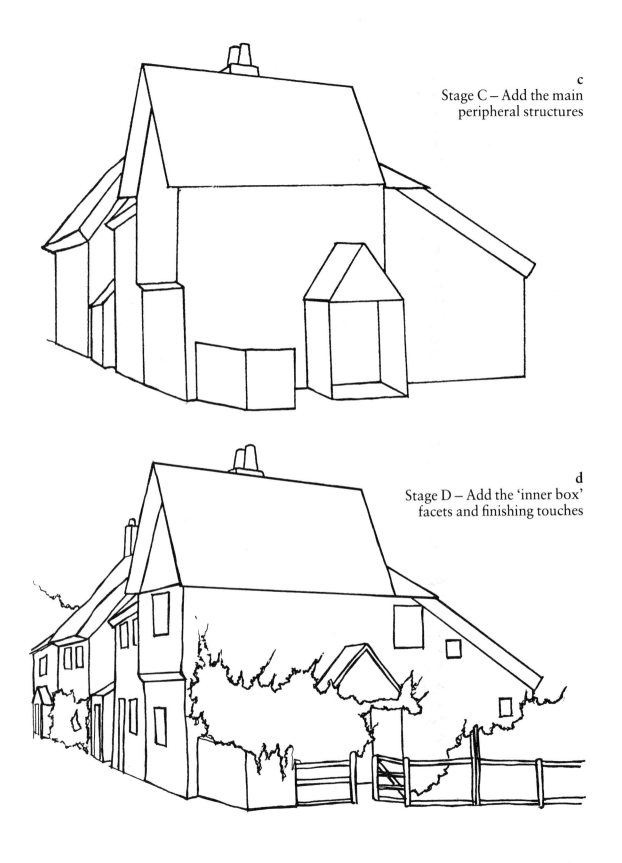

c
Stage C – Add the main peripheral structures

d
Stage D – Add the 'inner box' facets and finishing touches

Two possible reasons are given for the twists in these seemingly solid buildings. The first is that the late-medieval builders used unseasoned oak for the house frames (especially in rapidly developing towns where buildings were often required quickly). As these 'green' frames weathered over the years, they twisted and turned under the downward thrust of the roof, allowing the wattle-and-daub infilling to twist with them. The second explanation is that each village or parish was required to present the Crown with timber for the construction of the Navy's warships, and that on the decommissioning of these ships the hulls were returned to the appropriate villages and the now seasoned (but warped) oak was used by the carpenters in home-construction. This is equally feasible, bearing in mind the increasing lack of quality oak and its subsequent increase in price.

The size and shape of buildings vary too greatly to be put into any compact or concise form of guidance, but the majority can be put into boxes for drawing-purposes. Whilst I strongly advocate this semi-technical method of constructing drawings, it must never be seen as rigid or restrictive. If you can capture the 'feel' of a set of irregular buildings and record their shapes to your own satisfaction without box construction, all the better!

COMPOSITION

For good composition, look for a well-balanced scene and do check that everything you wish to include in your drawing fits onto the paper (chimney-pots are notorious for 'going off the top' of sheets of paper). A 1½ inch (4 cm) border around your subject often helps.

When you have completed the basic outline sketch for the whole composition, start working on the background first. The details in the background will be of an indistinct sketchy appearance and will generally be the lightest section of your drawing. Then move on through the middle ground, increasing the strength of tone and detail through to the foreground, which will contain the contrasts between the shadows and the highlights, and some intense detail.

Leave the darkest shadows until last – for two reasons. First, you can then judge the degree of heavy shading required to 'balance' the picture and to lift the highlights. Secondly, as this will be drawn with a very soft pencil (5–6B), you will not have to smudge the shadows as you work onto other parts of the composition.

On the subject of shadows, very few rules or firm guidelines can tell you what you will see. Simply draw them as you see them, looking under eaves and window-ledges in particular and at the sides of drainpipes. The one rule is that your light source can be in only one place at any one time, so all shadows must be on the same side of your composition.

So this is perspective and composition at their most basic – or, in other words, making a start. Making the first mark on a sheet of untouched white paper is in itself an intimidating action. But dismiss all fears of error and attack the picture with enthusiasm and enjoyment – and leave hesitation and caution until near the end of your composition. The initial 'groundwork' and sketching should be a pleasure, and a firm foundation to build on.

Illustration A
Woolpit, Suffolk: This type of house lends itself perfectly to 'box' construction for the beginner but contains sufficient detail to occupy the experienced artist for many hours

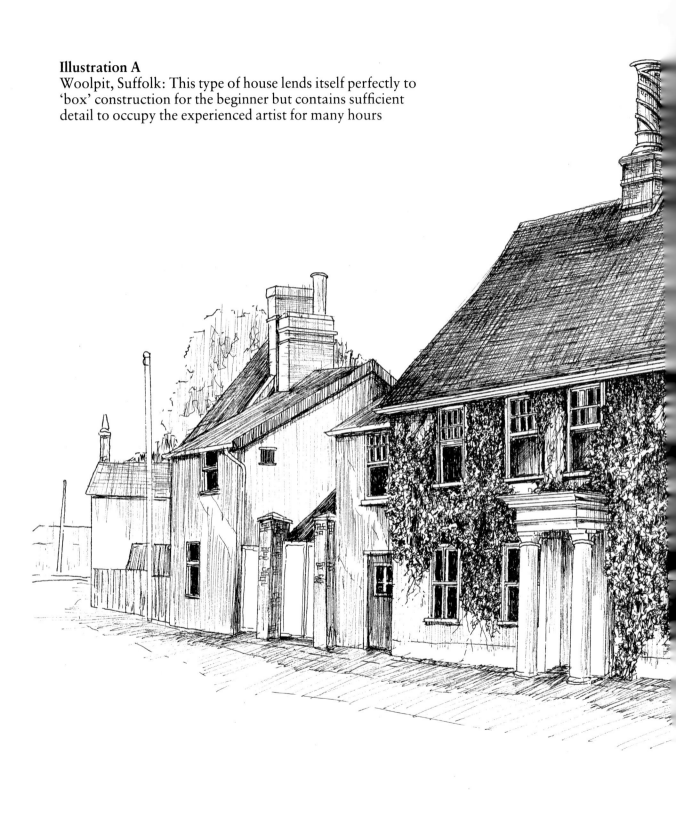

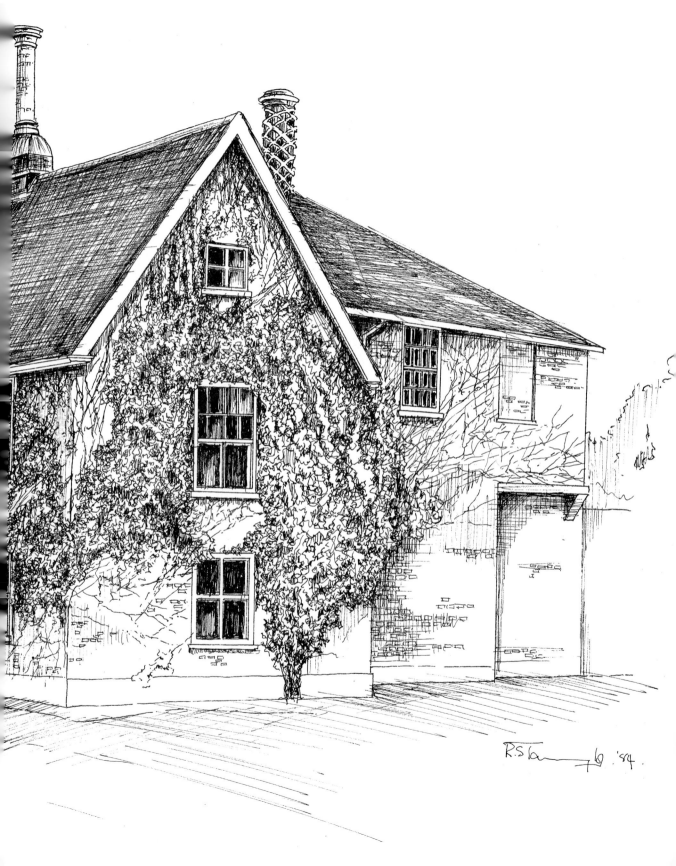

R.S.Tang⬡ '84.

Illustration A: Woolpit, Suffolk

One of the most instantly striking features of this building is the decorative set of chimney stacks, forming a dramatic skyline. The spiralled brickwork is a great challenge to draw and obviously indicative of the Tudor style of building. This is emphasized even more by the unusually steep pitch of the roof.

The second striking feature is the thickness of the ivy that grows freely along the walls, varying greatly in tone towards the ends of the leaner branches. The darkness of the ivy, however, does present a problem on a bright day. The strength of light will make the windows look considerably darker. This means that the window frames and the glazing bars have had to be drawn in very clearly, and the shading adjacent to this must, in fact, be darker than usual in order to emphasize the whiteness of the frames. This will serve to break up the potential confusion within the range of dark tones.

The other section that helps break up the ivy growth is the white pillared porch. Although the shading on the inner areas of the porch is important, a little self-restraint is necessary to allow the whiteness its full strength in order to form an adequate contrast to the ivy wall.

This house is, at its most basic, a simple box shape with many bits and pieces added on and is perfect for practising perspective-drawing techniques.

Illustration B: Woolpit, Suffolk

This building is a classic example of a small village jettied house, nestling in a row of timber-framed cottages with exposed beams and thatched roofs – all of them genuine as well.

This house has had many additions over its obviously long history, including the rear extension – this is evident by the seemingly unbalanced and illogical positioning of the two small windows. I would imagine that the wall and fence are also late additions, creating more space for the building of the porch.

The fabric of this building lends itself specifically to pen-and-ink drawing. The plastered walls, not being brand new, allow a little interpretation and 'artistic licence'. I tend to pick on any small flaws, dents or bulges in ageing plaster and emphasize these with a series of short vertical lines, suggesting an element of shading and putting some interest into an otherwise plain wall.

The exposed timber beams on the shaded front are interesting facets to draw and are very easy and straightforward to shade. The lead glazed window is also of interest, suggesting that the glass will be shaded lighter than the actual glazing bars (see Chapter 8). It is also of interest to note the variety of windows all within the one building.

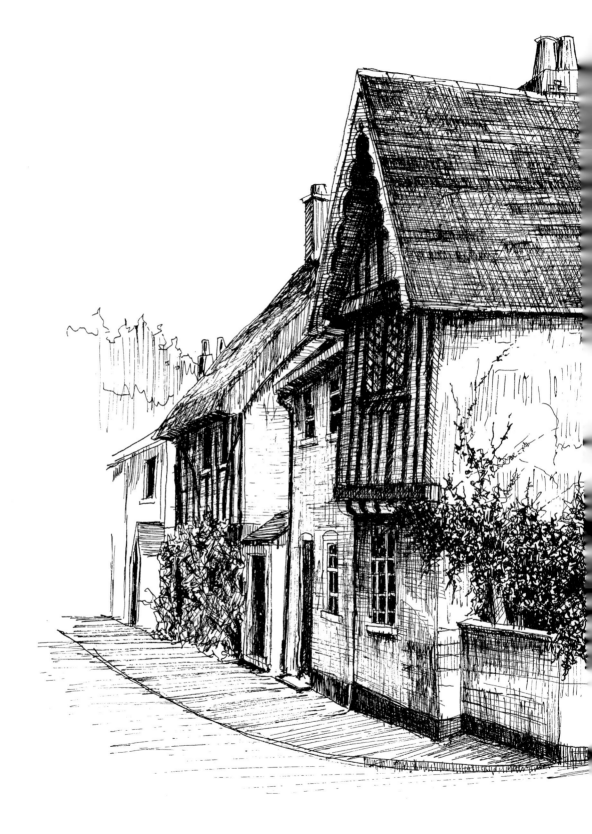

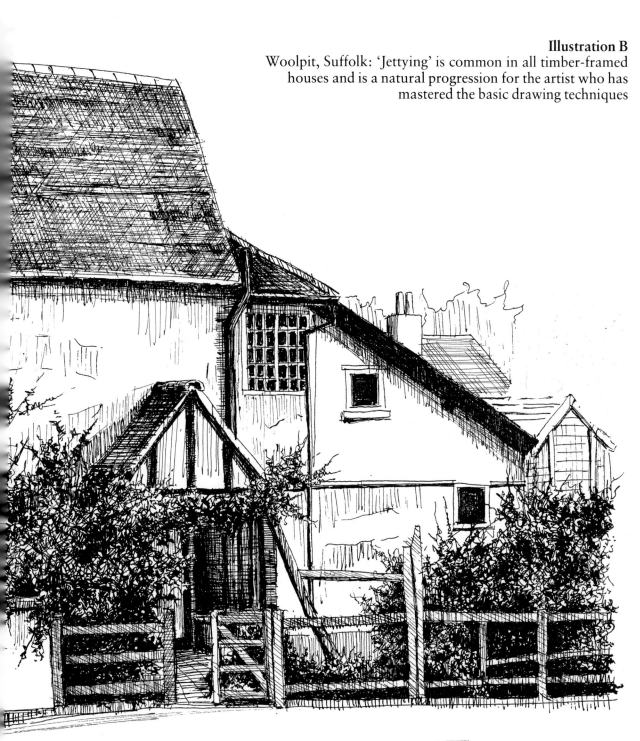

Illustration B
Woolpit, Suffolk: 'Jettying' is common in all timber-framed
houses and is a natural progression for the artist who has
mastered the basic drawing techniques

R.S.Taylor '85.
WOOLPIT. SUFFOLK.

Establishing the correct perspective is the first step to take when drawing buildings.

The near-geometric structure of many buildings lends itself to a simple method of perspective construction. Establish the basic box shape into which most buildings will fit.

For good composition, look for a well-balanced scene.

Begin with a basic outline sketch for the entire composition and then start work on the background first. Finish with the foreground, increasing strength of tone and detail as you go.

Draw shadows as you see them, looking under eaves and window ledges in particular and at the sides of drainpipes.

4. Panoramic Views

Having started to develop the essential skills of perspective, it can often be fun to ignore them completely and produce a technical plan representation or a panoramic view.

The angle of vision of the human eye is limited and increases the apparent angles towards the outer limits of your view. These angles often form the main area of interest in an architectural composition, as they often produce an intensity of highlight and shadow and form the lines of visual interest found along the rooftops and chimney-stacks. But occasionally it can be interesting to look at the total line of a group of buildings in any one street purely from a 'straight-on' viewpoint, excluding the perspective angles you would normally see. Whilst this 'flattens' the composition, the designs will come from the lines of the rooftops, the asymmetry of the windows, the variety of tone in the brickwork and the shape and size of the chimney-pots which can rarely be taken in visually as a whole and total unit but now can appear in line together, producing a wealth of visual contrast.

This exercise involves much cross-checking if your panoramic view is to be accurate. To begin with, you should obviously select the row of buildings for their visually interesting fronts. Look for a variety of window frames, different doorways and some assorted roofs (if only different tiles) as well as exposed brickwork next to plaster or rendering and possibly even fences next to brick walls.

Then select your starting-point. Positioned directly in front of the first group of three or four buildings you have chosen, make visual notes and accurate sketches, working from left to right. Concentrate on the centre frontage of this group of three, using this as your constant guide. Have confidence in your accuracy – there is no reason why you should not use a ruler to line up windows and other symmetrical details such as the height of the door frames, porches, window-boxes or other peripheral objects. Having gained a 'foundation' sketch, move on to the next set of three or four buildings, checking that the centre buildings overlap accurately.

Then check that the lines of windows,

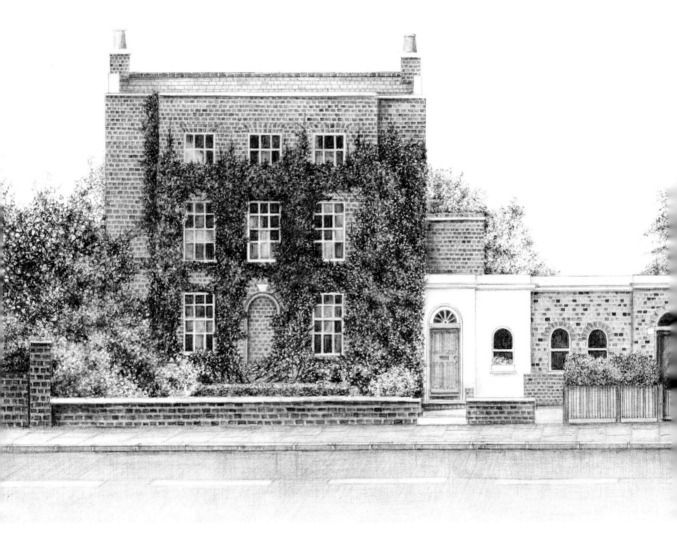

Illustration C
Silver Street, Enfield: Panoramic views are always interesting
to work on and are generally completed within your home.
They tend to resemble a jigsaw puzzle as you fit the row of
buildings together

42

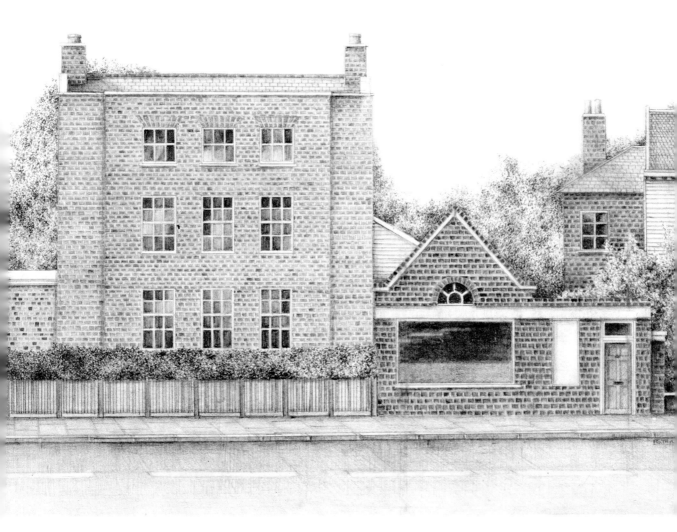

43

rooftops etc are all in the positions they should be. By now some shape should start to appear and an overall sense of design should be developing, so you can afford to decide how much further to develop the composition.

Panoramic views, by the very nature of their construction, lend themselves to studio or living-room (or even kitchen table) finish. Lining up the facets of each building as an integral part of the row can be like fitting a small jigsaw puzzle together, but more rewarding, as it is all your own work!

In exercises such as these it is quite acceptable to draw a set of parallel lines with a long ruler across your paper. This will enable you to line up windows, rooftops, door frames etc with a level of near architectural accuracy when you lay your sketches out in front of you. Having gone this far, there is no reason why you should not measure one building's width with a ruler and cross-check with all of the other buildings, making sure that they are proportionally accurate.

Panoramas are certainly more time-consuming than the average perspective or 'angled' view but are, without question, fun to draw and more original in the final result.

Illustration C: Silver Street, Enfield

This group of buildings is typical of our late-Georgian legacy. The long rows of red brick buildings maintain an ordered regularity yet sit easily with the wealth of changes that have occurred as the inhabitants have changed the outer appearances over the years.

This panoramic view was chosen initially for the range of textures and variety of brickwork that gave a contradictory asymmetry to the symmetrical Georgian three-storey townhouses that form the basis of this composition. The asymmetry of the surrounding buildings also makes for an interesting skyline, although this is considerably softened by the background row of trees.

The light that caught the windows was strong enough to create some glancing light from the odd pane, yet not so strong as to have burdened this composition with heavily cast shadows. The window surrounds merge with the brickwork at a first glance, but on closer scrutiny you can see that they are of a different type of coursing – it is also interesting to note that only the upper row of windows has window-ledges which require shading underneath to make them more pronounced.

Obviously a picture of this scale and detail could not have been undertaken 'on site', and it is the result of many hours of studio work.

The brickwork and tiles were drawn in lightly with an H pencil and shaded with a B and 2B. The depth of tone required for the creeping ivy on the walls meant that I could not use a darker pencil – the darkest tone achieved with a soft pencil on the ivy would have been negated by making the brickwork too dark. The foliage was drawn with a 4B and 6B to accentuate the darkest shadows.

One visual trick that I have used in this composition is to draw the buildings from a pure 'front-on' view with no evidence of perspective in either the angles of the buildings or the distance between them and the walls and fences. It would not, however, have been possible to omit perspective from

the pavement as the flagstones would appear to be standing on end. Consequently, I had to introduce a very slightly angled perspective into the foreground. This had to be slight or the visual effect would be confusing.

To draw a panoramic view look at the total line of a group of buildings in any one street from a 'straight-on' viewpoint, excluding the perspective angles you would normally see.

Select your starting-point, make visual notes and accurate sketches and work from left to right.

5. Building-fabrics

There is a wealth of variation to be found when looking at the actual fabric of buildings. From the wattle-and-daub walled buildings of the South, through the flint cottages of Norfolk and the rubble cottages of Cornwall to the quarried stone terraces of northern England, the building-materials will always reflect the locality.

Regional builders throughout history have been limited to the local materials available – with the exception, of course, of the affluent few who could afford to transport the bulky materials they lacked. This resulted in some highly individual building styles developing to cater for the qualities of these materials as the craftsmen's skills grew out of necessity. As the population gradually became more mobile, so the builders travelled farther and wider, taking their skills, techniques and knowledge with them to distant parts of the country.

Fortunately for the visual appearance of many small villages and towns today, many local building regulations stipulate the use of local materials for all new buildings. (Very few buildings can be put up in the Cotswold region unless they conform to the qualities of the beautiful Cotswold stone.) This maintains a uniformity within the village and, possibly more important, emphasizes the differences both geographical and geological between the country's regions.

The majority of buildings standing today have some form of brickwork visible, so the technique of drawing brickwork comes first.

BRICKWORK

Until the mid-seventeenth century, bricks were rare, being handmade, so the vast majority of walls were either stone or wattle-and-daub, easily replaced (as the rot set in) with the advent of cheaper, mass-produced bricks. It was the Victorians and their mass production that brought a sense of uniformity to brick buildings.

Whilst many 'hybrid' forms of brick coursing will be encountered throughout the country and occasionally within the one building, there are today, generally speaking, several recognizable types of brickwork to be found in English buildings.

Old bricks that have been weathered over

roughly sixty years tend to be of a similar tone – where new bricks have been added, or the occasional burnt brick has been used, an additional interest is created (**Diagram 5a**). The cement layers between bricks can be of a darker tone than the bricks themselves (**Diagram 5b**). The bricks may be found laid in different courses (**Diagram 5c** illustrates the style known as 'Flemish' coursing).

a
'Stretcher' bond

Diagram 5
Brick Coursing

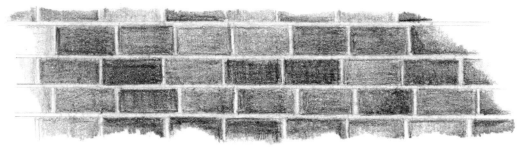

b
Light bricks with dark cement

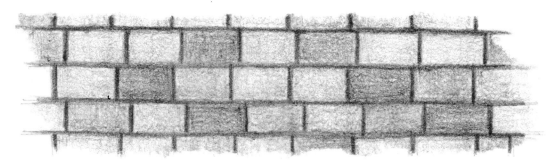

c
'Flemish' bond

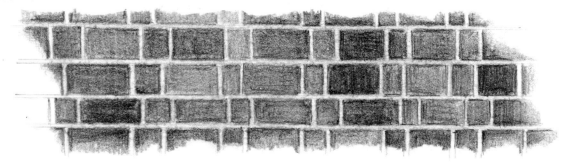

Another particularly interesting brick technique both structurally and aesthetically is one used by many sixteenth- and seventeenth-century builders, known as 'brick nogging' (**Diagram 5d**). The wattle-and-daub used to fill in the areas between timber frames had a limited life and would rot over a period of time. Bricks were often used as a replacement material and were set in a diagonal or 'herringbone' pattern. This will be frequently seen in the wool towns of East Anglia, especially Lavenham. Again, these reflect a little local glory, as the majority of pre-1800 bricks found in the Lavenham area will be of a most distinctive orange colour, signifying that they came from the nearby brickworks at Woolpit.

When drawing any of these variables I use

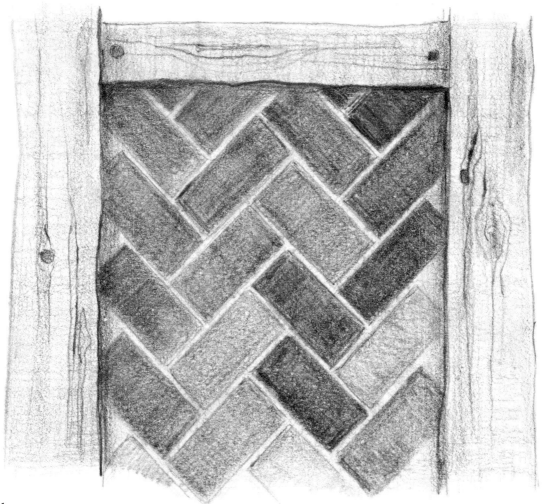

5d
Brick 'in-filling' or 'nogging'

the following method. First, establish the approximate size of layers in relation to the building size on your paper. This is vital as disproportionate brick courses could affect the entire scale of the building. If you are drawing a row of buildings, a bit of guess-work is quite in order – simply sketch in the size and number that you feel fit. If you are drawing any one specific building, it some-times helps to count the number of courses from the ground to the bottom of the ground-floor window. If these look correct, the others will follow accordingly and will look correct also. Then draw the corre-sponding narrow lines (**Diagram 6a**) to represent the cement layers between the brick courses, allowing the brick courses to form their own layers. Next draw in the individual brick sections (**6b**).

Then shade in the bricks (**6c**) using the following techniques. For light cement, shade lightly over all the brickwork using both vertical and horizontal strokes, and try to allow the edge of the pencil lead to do the work – this means keeping your pencil at an approximately twenty-degree angle to the paper. Apart from filling the cement gaps, this method of shading neutralizes any directional lines that may still show in the brickwork which will be emphasized even more by the use of the tip of the pencil. For darker cement, ensure that the gaps are darker than the bricks by actually drawing into the gaps with the tip of the pencil lead this time instead of just shading over them.

STONE

Stone is perhaps the second most popular building material. This is understandable due mainly to its availability, accessibility and cheapness. The method of drawing is the same for that of brick, only a greater element of personal judgement is required as the construction of stone buildings was far less structured or regimented. The reason for this is that most stone houses, cottages and terraces were built for the purely func-tional purpose of providing a roof over the heads of the occupants, mainly working people (fishermen, weavers and farm work-ers) who had little time to relax in any form of splendour. The three main forms are: ashlar – this involves building with large square or rectangular blocks (**Diagram 7a**); coursing – here the stones, although not necessarily of the same size or shape are laid in distinct courses (**7b**); and rubble – here the stones (or rubble) are laid at random with no real attention being paid to the aesthetic or visual qualities at the time of building (**7c**). These buildings were invari-ably practical and purely functional, but ironically, today they provide some of the most visually pleasing buildings and are cer-tainly one of the most interesting groups to draw.

When drawing bricks, only the dark or burnt ones need special attention – these are also always flat. Individual stones within a wall can be highly textured, especially rub-ble and flint, and warrant special attention.

49

Diagram 6 (a, b and c)
Drawing brickwork step by step

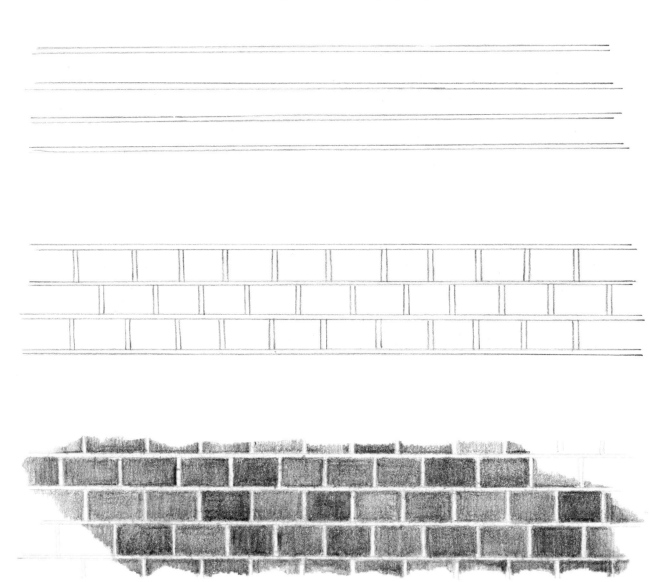

Diagram 7
Stone walls

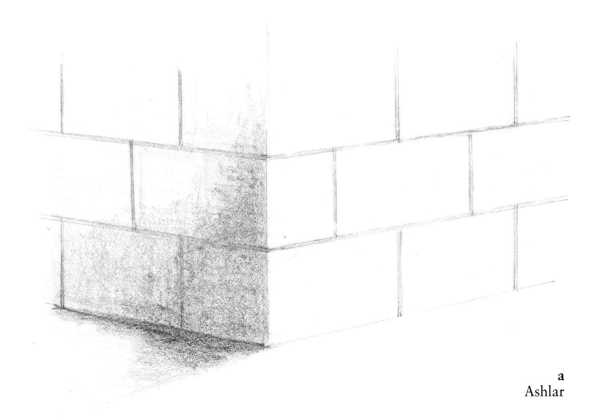

This can be contrasted with the technique used for bricks (as examined above). Individual shadows can often be cast by protruding stones onto the softer curves of rocks in the same wall.

As always, corners are of vital importance – perhaps even more important with stone buildings as they are frequently irregular in both size and shape. Keystones make an appearance here. They are the larger stones built up around the corners of walls made of cement and rubble as they may not have had the strength to support the thrust from the roof. (These are illustrated in **Diagrams 7b** and **7c.**)

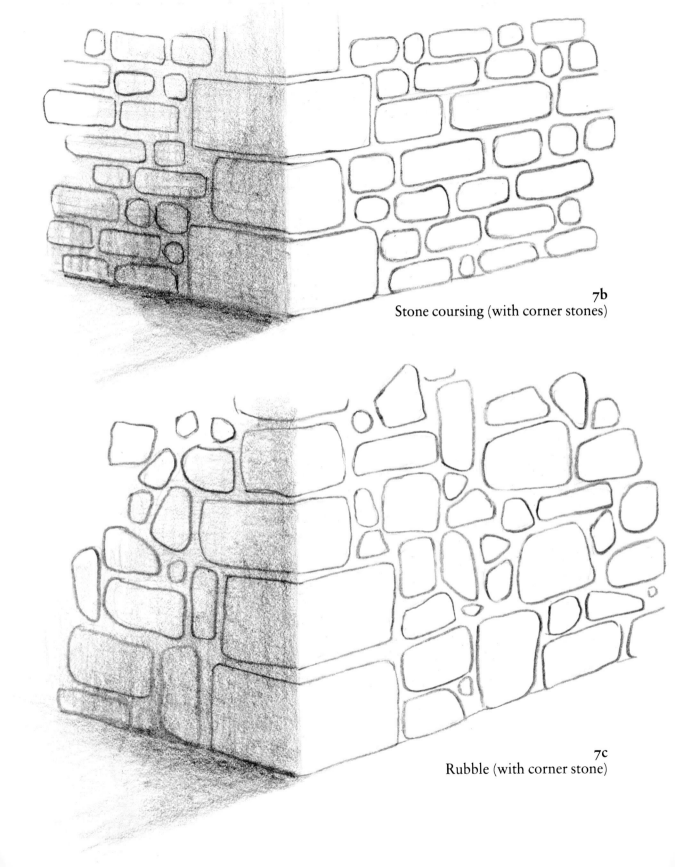

7b
Stone coursing (with corner stones)

7c
Rubble (with corner stone)

With the exception of plaster and stucco which, being plain, tend to take care of themselves as you draw in the windows and doors, the last important method of covering buildings (generally timber-framed) is the use of weatherboarding. This is a method of fabrication found predominantly in the south and east of England and was used to cover basic structures such as barns, windmills and labourers' cottages. It involved laying overlapping planks in downward courses, and they were often built onto a brick course at the bottom of the building to prevent the wood's rotting. The wood was then either whitewashed or tarred.

One of the reasons for the popularity of weatherboarding was its relative cheapness; it also provided a means of building outside the scope of the brick tax introduced in 1784 to raise funds for Britain's part in America's War of Independence. As this tax was levied on the number of bricks used, the effect was to increase the size of the indi-vidual bricks until subsequent legislation put a stop to this practice by regulating the maximum size of bricks allowed. The brick tax was eventually repealed in 1850.

The secret of drawing weatherboarding lies in the shading – the same method as is used for drawing clinker boats. As with bricks, it is essential to establish the approximate number of planks and their size in relation to the building. Then ensure that each plank casts a shadow onto the plank below (**Diagram 8a**). The shading for this will be darkest directly underneath the top plank, graduating to roughly halfway down the underlying plank. It is also important to ensure that the lines of the planks converge in line with the perspective established between the base of the building and the base line of the roof. The corner section is, again, vital. Look for an L-shaped right-angle frame containing and covering the otherwise exposed ends of the planks (**8b**).

Diagram 8
Weatherboarding

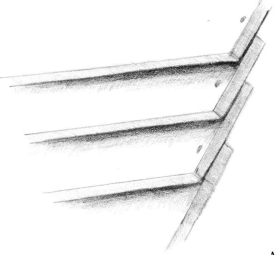

a
A look at the construction

53

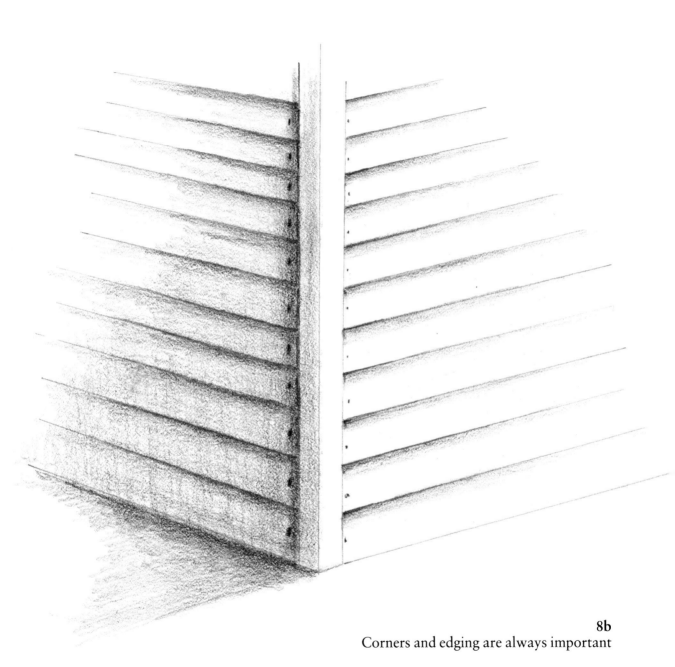

8b
Corners and edging are always important

The methods of drawing building-fabrics are straightforward and uncomplicated, although that for brickwork can be a little time-consuming if you decide to go for a fully representational and accurate illustration as opposed to a sketch in which the brickwork is suggested rather than drawn with architectural accuracy, a matter on which no firm guidelines can be given.

The level of finish to which you take your picture is a matter of personal preference and will generally manifest itself in the amount of detail you put into the fabric of your building. So be prepared to experiment – it is only from this that your individual style will develop.

Illustration D: Gentleman's Row, Enfield

This set of buildings is an excellent example of an illogical group of houses set together as one structure yet totally different in every imaginable aspect. Presumably erected as a small terrace of plain labourers' cottages, each house now asserts its individuality through the changes and renovations made by generations of owners. The window frames have all been changed, even to the extent of having dark glazing bars on one side and light glazing bars on the other – a double contrast. Also look for the smaller (yet equally important to overall impression) differences – the porches, the doors and the window surrounds.

The line of the rooftops is perhaps one of the most striking aspects of this composition, emphasized by the size and shape of the different chimneypots. The rooftops are set at different levels, and the overlaps serve as an additional point of interest. The dormer window set into the larger rooftop also serves to break up the monotony of the vast lines of tiles.

The second area of interest lies in the range of drawing skills that can be exercised on the building-fabric. The visual contrast of the white weatherboarding and the old brickwork is something worth seeking out when looking for a subject to draw. This is made to appear even more pronounced by the visual 'sandwiching' of the red brick section between the weatherboarding and the whitewashed brickwork on the other side. It would have been very easy to have left the whitewashed brickwork plain white, allowing the paper to work for itself, but close inspection will show that I have lightly drawn in the brick-course lines. This is

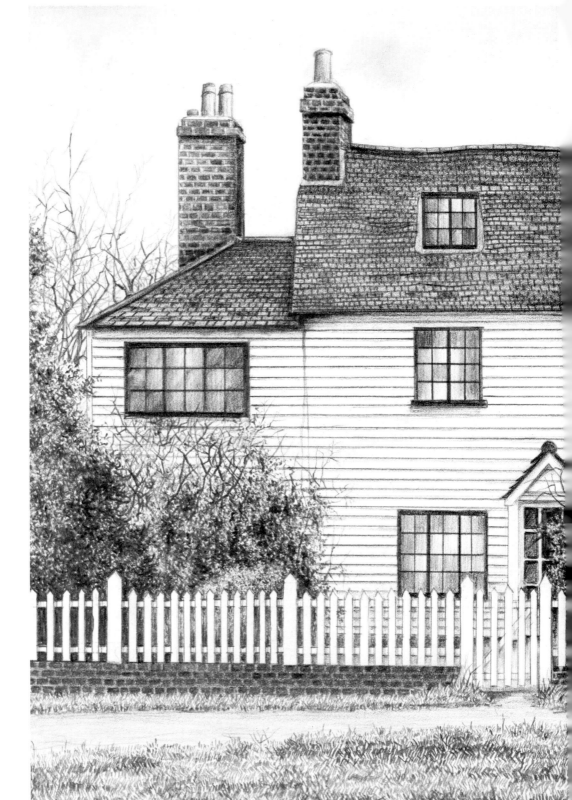

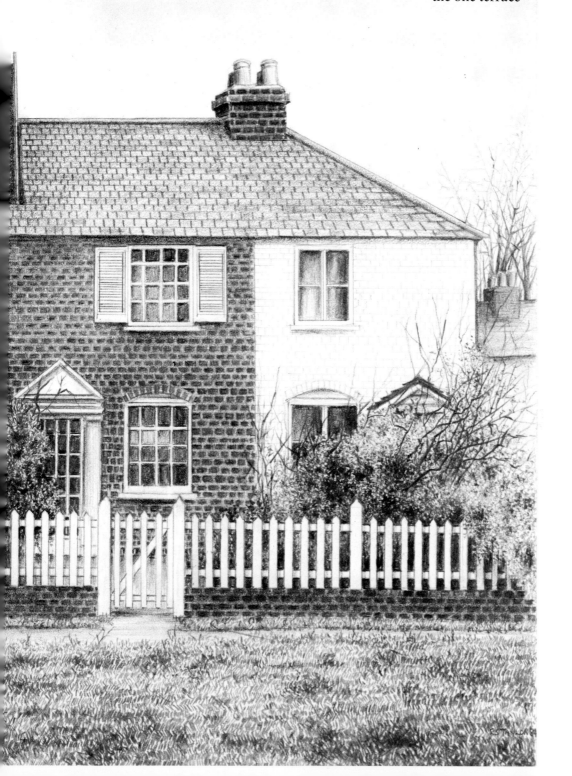

Gentleman's Row, Enfield: A fine example of a row of
cottages that contains a wealth of building materials within
the one terrace

important, to establish that the front of the building is not plastered.

Perhaps the most important feature of this drawing is the white fence, running through the entire length of the composition. Arguably, perhaps, the fence has not been 'drawn' – simply left to take shape as the brickwork and foliage behind have been drawn and shaded, using a 3B or 4B pencil emphasizing the whiteness of the plain paper and allowing it almost to develop a life of its own.

A final point that is relevant to this composition is that this was drawn in February. This is evident in the lack of background trees in bloom – a frequent feature of many drawings of country buildings. Drawing need not be restricted to the summer months (although I fully appreciate how unappealing a cold, windy February day can seem for drawing-purposes). The stark shapes formed by bare tree branches set against a cold, grey winter's sky can sometimes create an even more atmospheric background for a building than a hazy summer sky with soft cherry blossom hanging from the same trees four months later.

Illustration E: Norfolk Watermill

This privately owned building is a fine example of an authentically maintained working watermill. One of its most interesting features is the roof, with its combination of tiles and pantiles, demanding separate observations, techniques and tone (see Chapter 6), though remember that they are still part of a single unit.

As is typical of buildings that have had their functions changed (however minimally) over a period of years, a 'hotch-potch' of additions springs up – windows, doorways and doors. The assortment of barn doors with their Z planks makes an interesting study as many of them overlap and hang uneasily on their hinges when open. The windows in this composition also vary.

The depth of shading inside the doorways is graduated using a 5B pencil. A similar method of shading was also used under the bridge. The darkest possible shading had to be used there (6B), graduating downwards, although it was not possible to make the distinction between the shadows and the water level. Unlike the moving water in Illustration F, the water here required a different shading technique. A smooth method of shading is required here, using a B and 2B pencil, leaving the odd light section, suggesting ripples in anticipation of the slight movement on water created by a light breeze.

As always, the foliage is important, almost 'framing' the building. The delicacy of the hanging willow enforced some extra shading at the base so as to allow it to stand out against the grass, which was of a similar tone. This sometimes has to be done when the subtle tones of an early spring day deny positive definition.

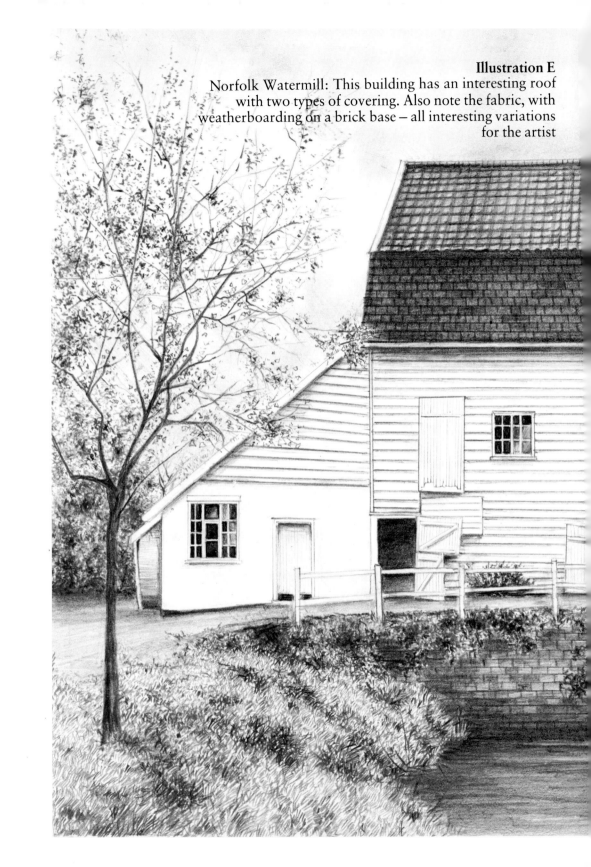

Illustration E
Norfolk Watermill: This building has an interesting roof with two types of covering. Also note the fabric, with weatherboarding on a brick base – all interesting variations for the artist

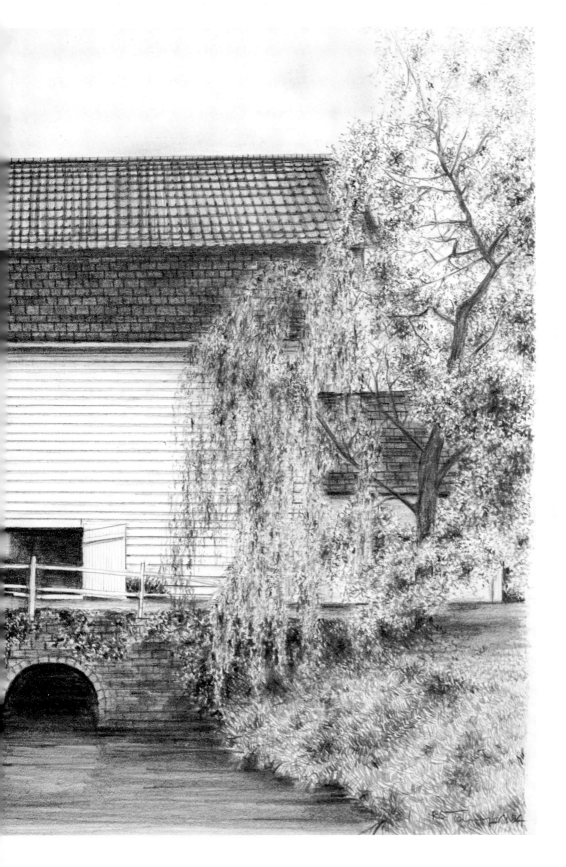

Building materials always reflect the locality in which you are drawing.

There are several recognizable types of brickwork to be found in English buildings – be aware of each.

Drawing stonework requires great care as it is less structured and regimented than brickwork.

Skilful shading is the key to drawing weatherboarding successfully.

6. Roofs:
Solid and Thatch

SOLID ROOFS

The most primitive of huts built to protect the early English natives had no roof as such but comprised of walls leaning together (Indian wigwam style) and meeting at the top. These structures were functional, as rain and snow ran off the walls, and winds whistled around them. Space was, however, severely limited and wider floor spaces were required. The evolution of the roof developed out of necessity as walls could no longer form the basic pyramid shape with such large bases.

The shapes of roofs have also developed through necessity, involving two major factors (besides the need to protect the inhabitants from the elements): the skilled labour and materials available to the builders and the regional considerations — chiefly weather conditions. The parapet gabled and Dutch gabled roofs of East Anglia, for example, developed to accommodate these (see **Appendix**). Immigrant wool-workers from the Netherlands brought with them their ideas and skills for building. The gabled roofs they built were well designed to protect the roof tiles from destruction by the strong winds that prevail in the East Anglian lowlands. Similarly, the blue/grey slates that are so prevalent on the roofs of the northern stone cottages are the most logical form of roof covering given the proximity of the quarries, the abundance of the material and its suitability as a roof covering.

To start this section, it is perhaps best to examine the types of roof shapes you are likely to encounter on detached or semi-detached buildings — terraced buildings often share the same roof shape, but this is by no means a rule.

In small villages where buildings have been added to a row, one after another, some fascinating skylines can be found which not only appeal visually but also help to observe the historical development of the building, its successes, its affluence and even perhaps its disasters. Buildings always have the capacity for making statements about social history.

The shapes illustrated in **Diagram 9** are the basic constructional shapes, although an assortment of dormer windows is often to be found protruding from all types of roofs.

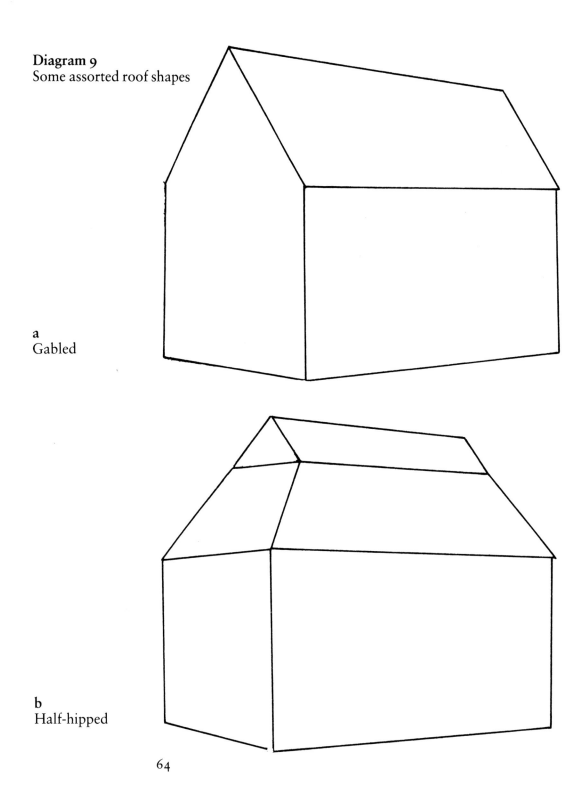

Diagram 9
Some assorted roof shapes

a
Gabled

b
Half-hipped

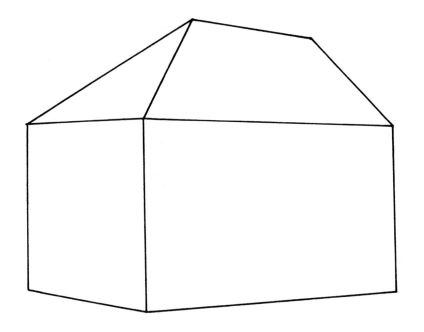

c
Hipped

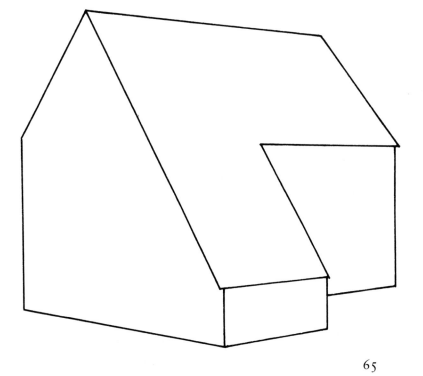

d
Catslide

As most houses constructed before 1500 had no upper floor as such (only a storage space under the roof, lighting was necessary only on the lower levels. As human occupation of upper floors developed, so did the dormer windows, being initially little more than gaps cut into the roof. These soon developed into more elaborate windows and, finally, into the loft extensions frequently seen today, introducing a welcome element of non-conformity to many post-war housing estates. **Diagram** 10 illustrates a few typical examples.

These windows can also be constructed within a three-dimensional box shape, starting the box at the base of the roof. One point to note here is that you will generally be looking up into the eaves and will see shading on one side only.

From the artist's point of view, when looking for subjects to draw, two main types of covering exist – slates or plain tiles and pantiles.

Although slate roofs are to be found throughout the country wherever the material occurred naturally (e.g. in parts of Devon, Cornwall, the Lake District and Leicestershire), by far the most usual type is the blue-grey slate which originates from Wales. Although originally slate was used as a roofing material only in areas close to the quarries, it increased in popularity as transportation costs diminished and its use in villages and towns became widespread, especially after 1831 when the tax on slate was removed. Plain tiles were a popular form of fire-resistant roofing material in areas where slate did not occur naturally.

Although both the size and the mode of manufacture of the tiles were regularized as early as 1477, there would seem to be many regional variations in their dimensions. Understandably, to the architect the lack of distinction between plain tiles and slates may be abhorrent, but for us the distinction is not really worth labouring over – only the colour and its subsequent tone are important at this stage.

Slates and tiles are laid in the same manner, generally following one of two methods. Both involve overlapping from the top downwards, but in certain regions the tiles of the apex of the roof are the smallest, graduating to the largest at the bottom of the roof. This creates an intensity of perspective – a rare occasion in which the architects of labourers' houses/cottages gave some thought to their visual appearance.

As shown in **Diagram** 11, the method I use for drawing tiled roofs is initially (having established the shape and size of the roof) to draw in the approximate number of courses as straight lines, always following the perspective of the roof – i.e. ensuring that the first line drawn follows the line of the apex and the last line follows the bottom, with the lines converging correspondingly. Next the actual tiles are drawn in, keeping the lines parallel with the two lines of the roof edges. To add to the perspective I always ensure that the tiles are a little more compressed at the far end, creating an effect similar to the perspective illusion based on the smallest tiles being hung at the top of the roof.

a

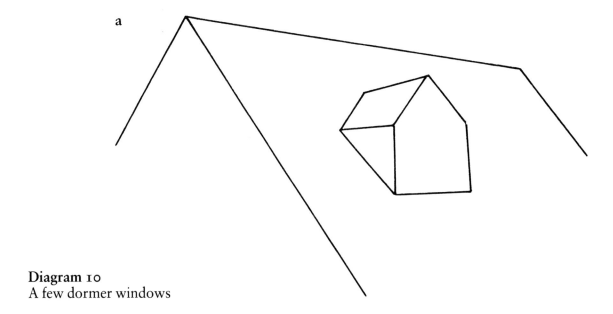

Diagram 10
A few dormer windows

b

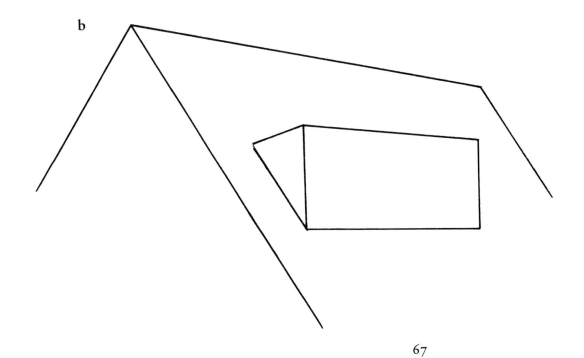

67

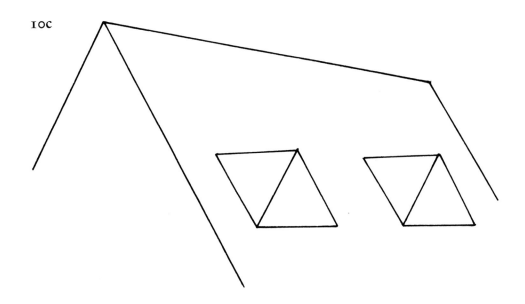

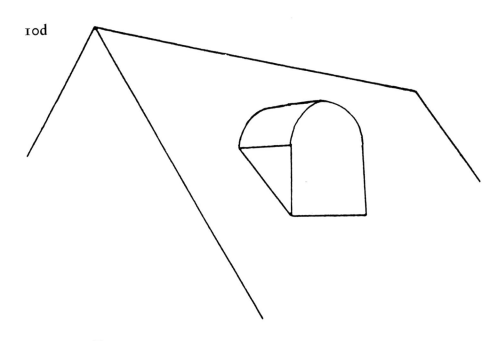

Diagram 11
Drawing tiled roofs

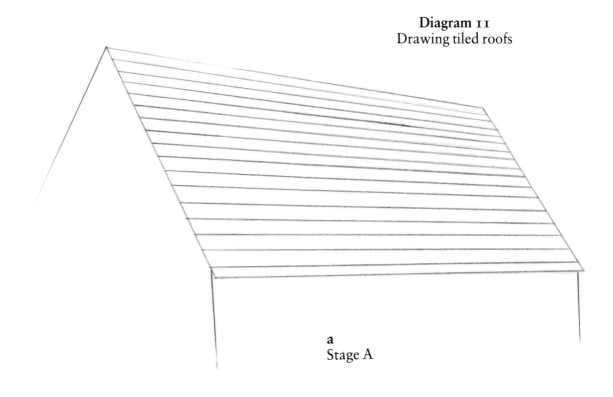

a
Stage A

To shade, I use a cross-hatching method, keeping both strokes parallel with the course lines and the tile direction lines to give an overall tone. Finally, as with the brickwork, I pick out a few tiles for darkening in order to break up the large area of solid shading emphasizing that the roof is, in fact, made up of single units, and to emphasize the lines of the courses I re-draw the course lines, achieving the effect on the shadows being cast on the downward coursing.

Pantiles, due to their awkward shape, require a slightly different drawing approach (**Diagram 12**). They are laid in parallel courses, creating long indentations and ridges running down the roof and a general visually attractive effect. The method I use for drawing is, in the first instance, similar to that for tiles and slates. Start off by constructing a grid of horizontal converging lines and then add the downward lines at the same angle as the slope of the roof, representing the width of each downward row of pantiles. Next, draw every row of tiles as in the diagram, creating a wave-like effect across the roof, ensuring that the overlap is visible. This is the key to drawing pantiles. Slates overlap only downwards, not across the line of the roof as well.

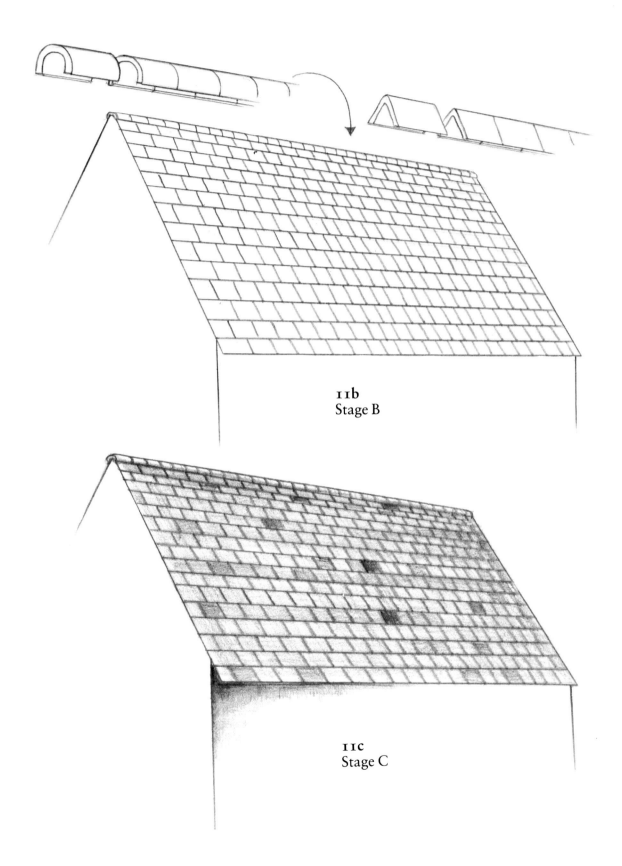

11b
Stage B

11c
Stage C

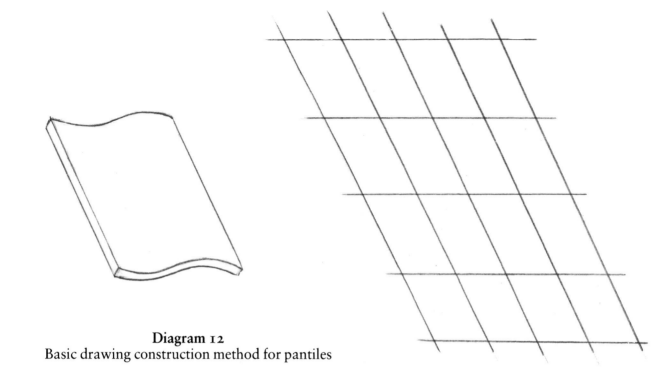

Diagram 12
Basic drawing construction method for pantiles

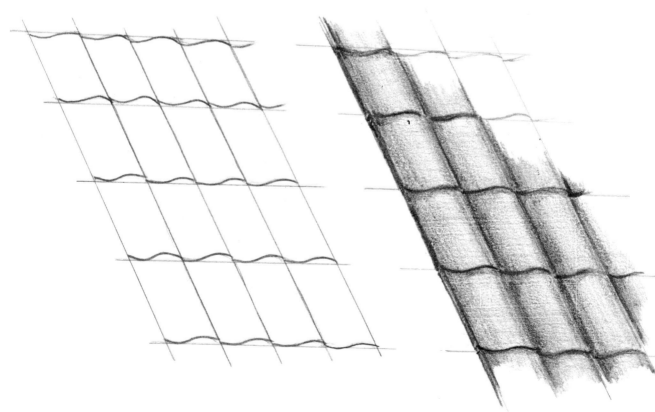

The next stage is perhaps the most important. Shade the indented sections, graduating the tone so it becomes lighter as you follow the upward line of the course. If you are drawing with a pencil, start with the tip, turning the lead as you shade until you are shading the lightest end of the graduation with the edge. If drawing with a pen, simply increase the pressure and intensity of marks in the darkest section, releasing pressure and distributing the marks more widely towards the outer end of the graduation. Lastly, put a light covering of cross-hatching across the roof to prevent its looking too smooth.

The final area to mention is that of eaves and gables. Some roofs simply come to an abrupt end, others may have simple gables, others are highly elaborate. The overlapping roofs will invariably cast a downward graduated shadow forming an important area of visual interest, and the gables with their variety of shapes give a blank wall an aesthetically interesting visual line to draw.

THATCHED ROOFS

Thatched roofs can still be found throughout the country, many providing a very good service to their owners. Thatch was initially used by builders as a cheap method of roof covering. It was later discovered that it could not be matched for its insulating properties – its life was, however, limited, unlike its capacity for catching fire and for harbouring a vast array of vermin.

Many thatched properties exist today as a result of Victorian builders' romanticized view of rustic England, which they cultivated by building 'picturesque' cottages, even 'model villages', consisting of what were essentially thatched terraces. These were frequently built on the approaches to an estate or manor house in order to make the drive to the home more pleasant for the landlord's guests. Consequently highly elaborate and often 'overdone' thatch designs are dotted around the countryside. Many of their styles were taken from the design books of the day which were full of elaborate and decorative plans. This is the chief reason why many thatch shapes are so similar throughout the country. They are, however, great fun to draw.

The basic thatch shapes are shown in **Diagram 13** but many variations exist, including the addition of dormer windows and the formation of a 'catslide' roof by an extension being added.

The older original thatched roofs are generally very plain, straightforward and functional, such as the beehive roof. This is often in stark contrast to the style introduced during the late-eighteenth century which often had some elaborate decorations worked into the thatch, especially on the apex of the roof where a certain level of securement was always required. The pattern most frequently used is a 'cross-stitch' (**Diagram 14**), using stronger materials that are usually lighter in tone than the actual thatch. It is most important, therefore, to sketch this pattern in before shading, using a double line for each light thread and then shade behind it, rather like constructing the previously described brick courses, leaving an emphasized and highlighted crown to the roof.

For shading and toning thatch, I use a diagonal cross-hatching technique, using only short, sharp strokes and only in patches, emphasizing the roughness of the

a

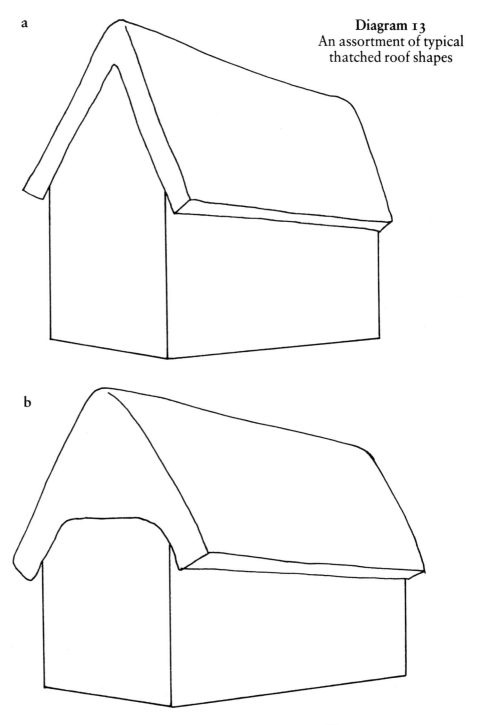

Diagram 13
An assortment of typical
thatched roof shapes

b

13c

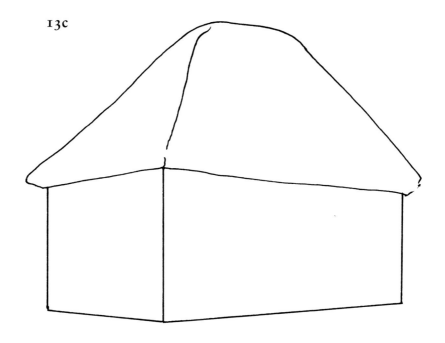

13d

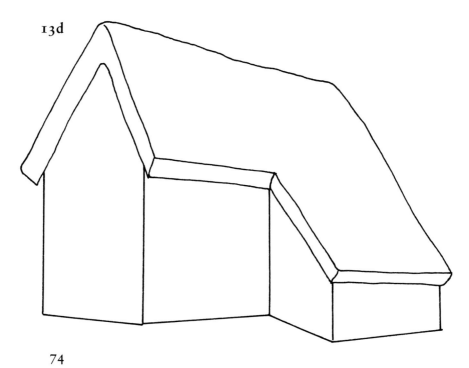

13e

13f

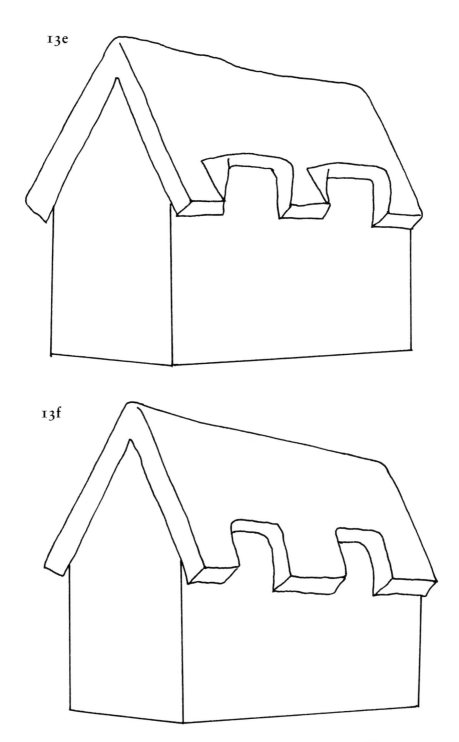

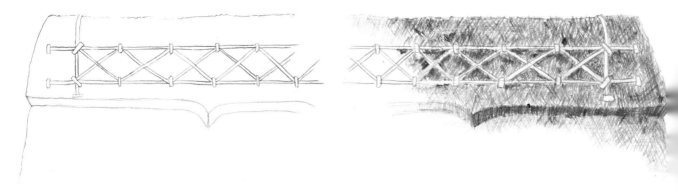

Diagram 14
'Binding' or 'securement' for thatch and cross-hatch shading
to create thatch texture

material. This is a case for drawing with a 2B pencil and using only the sharpest point to create the thatch texture. The eaves will invariably be the darkest and probably shaded, using the same technique of applying only the sharpest point, but with a 3B or 4B pencil.

One of the most enjoyable aspects of drawing thatched roofs is that you are not bound by the rigidity of the solid roof lines. The curves and textures make a welcome change from the sharpness of conventional roofs, and the shadows cast produce some fascinating shapes for the enquiring artist to tackle.

Roofs are more than simply the finishing touches to a house that serve to keep out the weather. They are an integral part of the building structure and possibly have the greatest capacity for originality and creativity. After all, a wall can never be much more than a wall. A roof, however, can display a multitude of different facets. Slate, stone and thatch have the capability of capturing and reflecting light, casting and creating intricate or heavy shadows onto the street or the houses opposite. The textures can be exciting to draw and a constant source of fascination to investigate.

Do investigate roofs – they can tell you quite a lot about the previous and, sometimes, present owners, apart from providing a solid anchor for beginning the basic toning and shading of any composition.

Illustration F: Pakenham Mill, Suffolk

This is certainly one of my favourites – chiefly because it encompasses so many features within the one composition: brickwork, weatherboarding, slates, pantiles, trees, grass, water and a winding lane.

Pakenham Mill is a good example of a working watermill, set in a beautifully picturesque setting – in fact, it would not be too hard to imagine one of Constable's famous waggons coming into the picture from the far end of the lane. The sharp contrast of the tarred brickwork set against the whitewashed plasterwork, topped by the heavy dark-tiled roof makes a visually interesting feature. This is emphasized by the shading cast from the white supports, drawn lightly with a B pencil.

The steep pitch of the pantiled roof has a gentle sweeping appearance which fits in well with the other curves and meandering slopes that prevail throughout this composition. The brightness of the hot summer's day is evident by the darkness of the windows, drawn extremely carefully with a 4B pencil, but perhaps the most atmospheric features of this composition are the amount and fullness of the foliage in both the foreground and background. The overgrown foreground, including both flowerheads and reeds, suggests a certain 'lushness', and the wild, unshaped bushes that taper off along the side of the lane are suggestive of a season of warmth and growth. The overall atmosphere is enhanced by the mottled shadows cast onto the bridge wall.

The effect of moving water is produced by leaving the main current stream white, with only a few short streaks drawn into it. This then eventually graduates into the main stream at the end of its run. The effect is heightened by the darker shading at the base of the bridge, highlighting the whiteness of the moving water.

Finally, this composition typifies what I most enjoy about drawing traditional buildings. A wealth of atmosphere, textures and history is embodied within this one scene – a scene in which you can relax, draw and easily drift back in time.

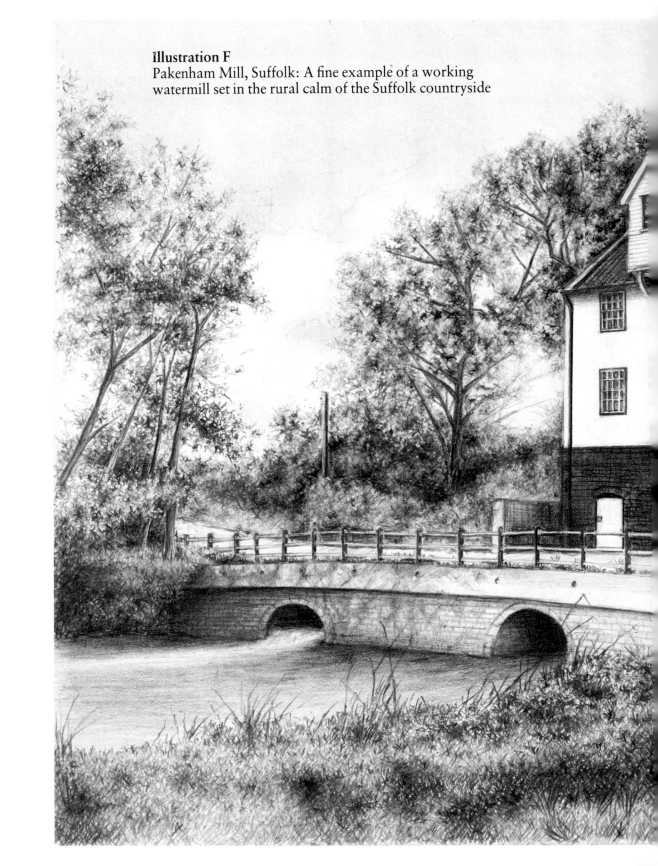

Illustration F
Pakenham Mill, Suffolk: A fine example of a working
watermill set in the rural calm of the Suffolk countryside

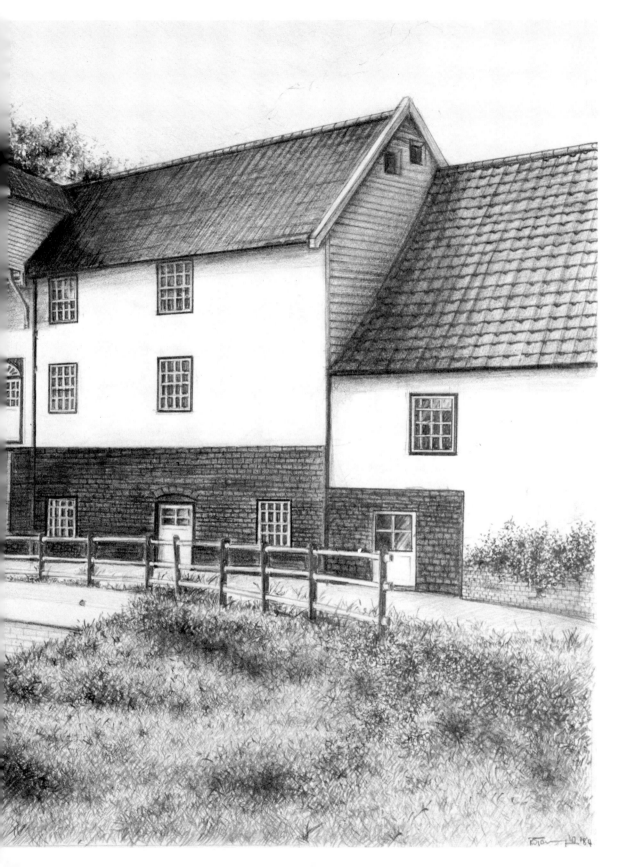

For tiled roofs always follow the perspective of the roof – ensure that the first line drawn follows the line of the apex and the last line follows the bottom, with the lines converging correspondingly.

For shading and toning thatched roofs use diagonal cross-hatching with patchy, short, sharp strokes to emphasize the roughness of the material.

7. Chimney-pots and Stacks

If we look at the entire history of building from the mud huts of the Dark Ages until today, chimneys must be seen as a relatively new development. Many medieval halls were constructed without any intended gap for smoke to escape from, above the roaring log fire in the centre of the hall. The disadvantages of this system rapidly became obvious, with the onset of bronchial and chest disease, not to mention the endless filth and soot.

Strangely enough, the idea of channelling smoke through intended passages did not really catch on until well into the sixteenth century. Consequently, many older buildings have had chimneys added as an afterthought, leaving the chimney in a seemingly illogical position in view of the extensions added over the years. Chimney-pots that once stood square in the centre of roofs may also have suffered from extensions and may now look out of place. But this is half the fun of drawing buildings, this lack of uniformity, presenting some varied and exciting skylines and often adding interest to a seemingly dull terrace, presenting you with a challenging composition in some of the most apparently uninspired streets.

Also, as these chimneys were often constructed during a period different from that of the building, they may not always be of the same materials. This is another reason for the style of brickwork or decoration not always being in keeping with that of the main body of the building. Invariably, however, they will be built of locally available materials which are possibly more suited to construction today than the original building materials of the original house.

It is particularly difficult to write here in detail about the types of chimneys you are likely to encounter on any drawing expedition as little uniformity really exists, but look out for the highly decorative spiral Tudor stacks, which have a distinct style of their own, standing as a testimony to the skill of the bricklayers of the day, and for the circular stone pots of the West Country which tend to assert their own individuality.

The other variable to look for is the design of the chimney-pots on top of the stack. They may even vary within the same stack

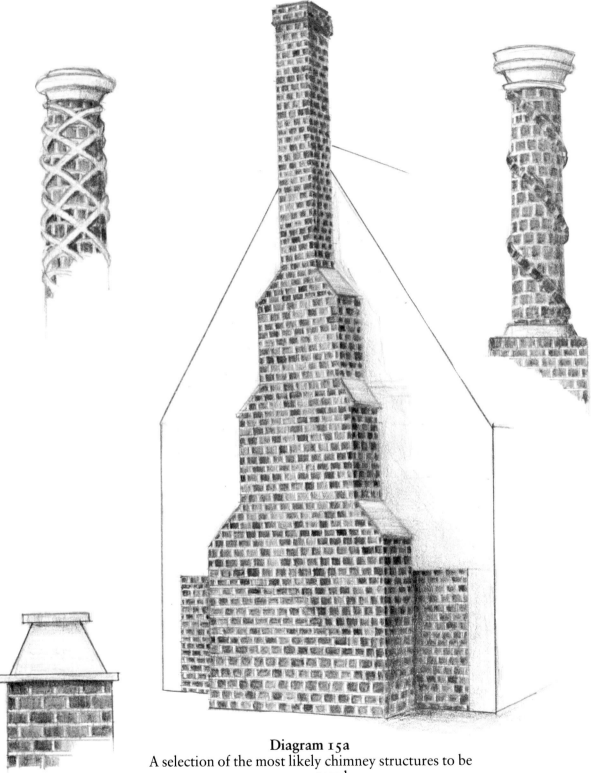

Diagram 15a
A selection of the most likely chimney structures to be
encountered

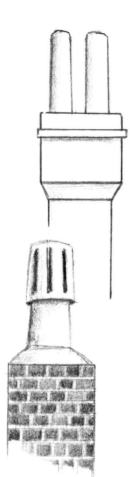

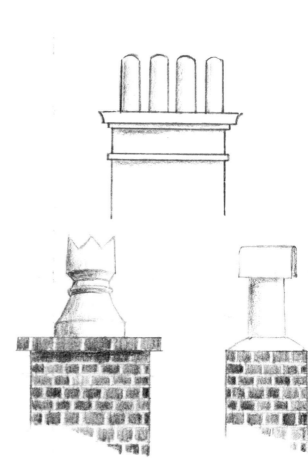

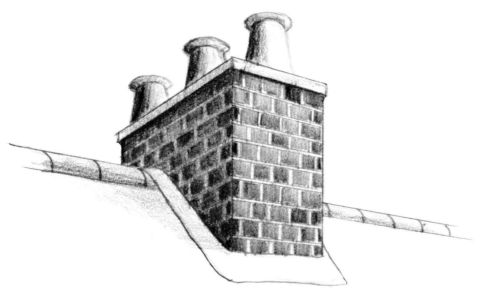

15b
The chimney is invariably the highest point of the building and warrants the sharpest perspective

15c
An example of graduated shading

and will undoubtedly vary considerably from house to house, often within the same terrace.

Apart from these, it is a matter of searching the corners of towns and villages for the crooked stack, the multiple set of pots or the solitary tall stack penetrating the skyline.

Diagram 15a illustrates a good selection of the types of chimneys you will see, including the Tudor spiralled stacks and the massive outside chimney-breasts.

There are also a few technical points to bear in mind. First, the top of the chimney, generally being the highest point of the building, will represent the peak of your perspective construction and will, consequently, have the sharpest angle. It is also vital that your vertical lines are still parallel with all others concerning the building you

are drawing, especially the outer edges of the house, as there are few things worse to look at than a sloping chimney-stack. If it is crooked or leaning, the perspective within the stack will still look correct, but incorrect perspective will stand out like a sore thumb. From the ground you will always be looking up at chimneys and will rarely see the point where the pots are attached to the stack. This is an important perspective point to be aware of, as this means that the circular effect on pots will be achieved through graduated shading and the curve on the top of the pot (15b). Most chimney-pots are circular and do require this form of graduated shading. This technique is exactly the same for pen and pencil and is a simple matter of shading from one side to another, easing off the pressure halfway around, creating a circular effect in the process (15c).

Very rarely can stacks built through the roof be seen without a lead or aluminium 'apron'. This is an important element for drawing as it breaks the continuous texture of the slate or tiles and helps to project the chimney as a separate structure. The shadow cast from the chimney is also important, as it could fall at any angle along the downward line of the roof or even, in narrow streets, onto the walls of the houses opposite.

To conclude, chimney-pots and stacks must be seen as an integral part of any building, although they may not have been at its initial conception. The height from the ground gives them the sharpest of perspective angles which must at all times be correct, otherwise an uneven or incorrect stack can easily become the visual centre of attraction for an otherwise skilful picture.

Illustration G: Mill Lane, Woolpit

Corner buildings such as this are perfect for practising perspective. Apart from the basic building 'block', the two roads meeting at a central point provide a fundamental ground structure on which to build your perspective lines. This is also a good example of drawing through the box-construction method. The chimney-breast and the built-on extension both serve as excellent facets to practise on. Finally, having sketched the basic framework and checked the perspective, much of this will be altered: very few lines are straight on buildings as old as this – the walls are slightly bowed, the plaster bulges in some areas and none of the roof lines is perfectly straight, warping under the weight of the pantiles.

The chimney-stacks and pots form one of the most important features of this picture – they do not all belong to the same home, but it is difficult to assess which ones belong to the one being drawn – with the exception of the large chimney-breast.

From the artist's point of view, this building can be divided into two sections: the lefthand side (an obvious extension built on at some time) and the original building occupying the centre and right. The pantiled roof on the extension requires careful attention. But one more subtle difference, perhaps, warrants attention: although the walls of the extension have been white-washed, the brickwork can still be seen – this is achieved by selective use of a few brick-course lines, indicating the courses without drawing every one in. The main bulk of the building is plastered and is consequently shaded with straight vertical lines only.

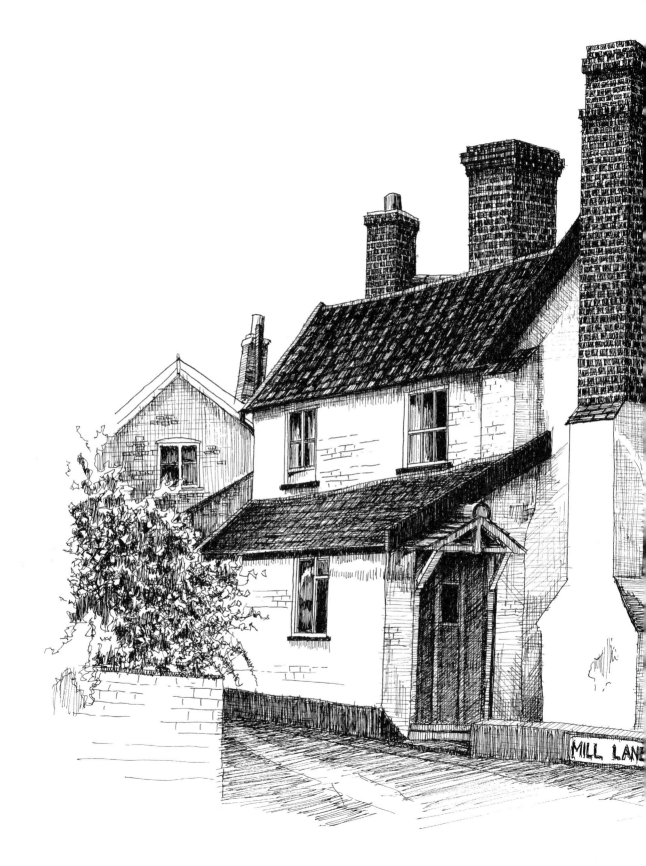

MILL LANE

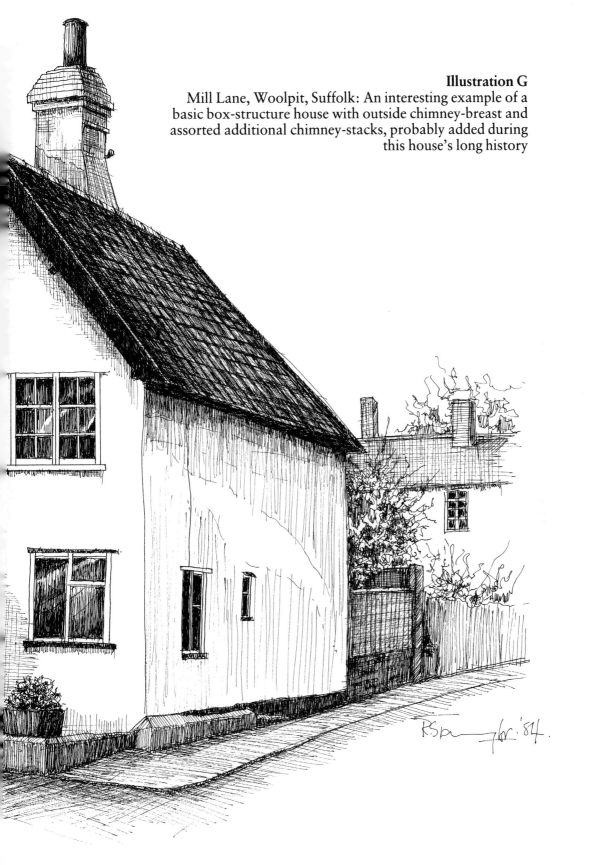

Illustration G
Mill Lane, Woolpit, Suffolk: An interesting example of a
basic box-structure house with outside chimney-breast and
assorted additional chimney-stacks, probably added during
this house's long history

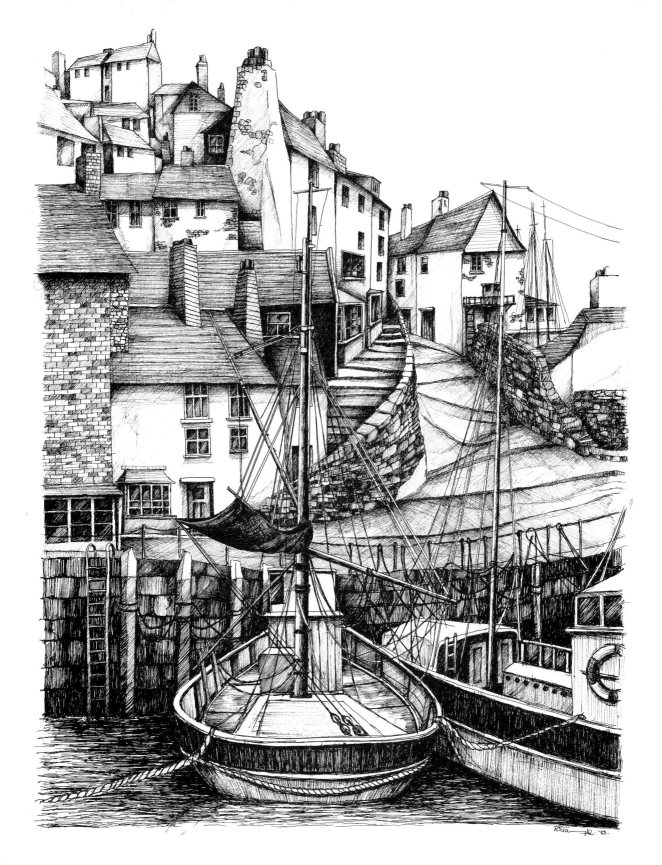

With white buildings, it is important to draw a firm base, tonally, for them to stand on – pavements and roads are generally dark and warrant a few minutes' drawing-time.

Illustration H: Brixham Harbour, Devon

This picture is more of a 'townscape' than a specific study of any one building or group.

Within this composition, every type of brick and stone formation can be found, from the massive blocks of the harbour wall to brickwork on the chimney-stacks. But the main area of visual interest is the way in which the houses sit, often precariously, on the edge of the hill at some very odd angle, with the buildings in the background appearing as little other than boxes with windows, leaving the detail for the foreground. Another interesting aspect is the way in which the shadows fall onto other buildings, creating some interesting shapes themselves.

The chimney-stacks in any 'townscape' are generally worthy of close examination. Occasionally one will stand out from the others – in this case it is the huge stack with stone edging and some cracked plaster just off centre, and it forms a major perpendicular element in the composition.

Illustration H

Brixham Harbour, Devon: Much of the visual charm of this town lies in the assortment of 'box' houses that climb the steep hill, and their corresponding chimney-stacks that form the erratic skyline

The winding paths, with corresponding steps and stone wall, that curve in waves through the picture are more important compositional elements. The rubble stones that make up this wall form a wide variety of tone and contrast sharply with the flat ridged, wave-like cement that forms the main path. The intensity of perspective along the buildings on the edge of the path warrants examination; the exaggerated sharpness of the angles may seem a little too intense but is necessary to create the awkward effect of perspective on a hill.

The hewn blocks of solid stone that make up the harbour wall are of great importance, being by far the darkest section of the picture, with a little weathering and staining from the sea included in this. The wall also casts notable shadows onto the water, although the light sections still need to be shaded around in order to create the 'ripple' effect always evident in moving water.

Apart from the boats in the foreground and the interesting lines and angles always created by their rigging, the main area of interest lies in the box-type shapes formed by the assortment of buildings as they are stacked uneasily on top of each other towards the skyline – a feature of any village or town built on a hill and a challenge to the architectural artist.

> Avoid a sloping chimney-stack by ensuring that the vertical lines of the chimney remain parallel with those of the house.

8. Windows

Windows form some of the most distinctive features, being positioned prominently in the walls, and do, without doubt, help establish the character of buildings, both visually and historically. Windows, perhaps more than anything, give you an idea of when the building was first constructed.

Whilst the value of windows (or gaps in the walls) was realized in the Dark Ages, they were a luxury for many years to come. Glass was expensive, well beyond the means of the average person, as mass production had not yet come into being. Glazing was, consequently, restricted to ecclesiastical buildings (see Chapter 10) and the homes of the very wealthy. So the majority had to make do with wooden shutters or cloth to keep out the winds, rain and snows of winter. It was only the mass production of glass during the eighteenth century that resulted in glazing becoming the norm in all homes. But this was soon counter-acted by a window tax imposed in the late-seventeenth century, which resulted in many windows being 'bricked in' in order to avoid payment. (This is a particular area of interest for the artist, as the bricks in these 'bricked-in' windows are frequently of a lighter tone, having been added during a period later than that of the initial construction.) However, eventually glass became affordable to all and gave a new major visual aspect to all buildings.

From the artist's viewpoint there are three main elements to look for in windows: the window surround, which will invariably be brick or stone, except in weatherboarded houses where it will, of course, be wooden; the window frame, which will more often than not be made of wood, with the odd exception of the few metal frames, and the glazing bars – these need a few specific tips on drawing. As most of the window frames and glazing bars you meet will be white, the glass must be shaded a darker tone in order to make the bars stand out. (Again the lead light windows of Tudor buildings and churches will be the exception to the rule here.) I use the following method of drawing (**Diagram 16**).

This is easy from a 'front-on' view. If your building is viewed from an angle, remember

Diagram 16
Stages of basic window construction

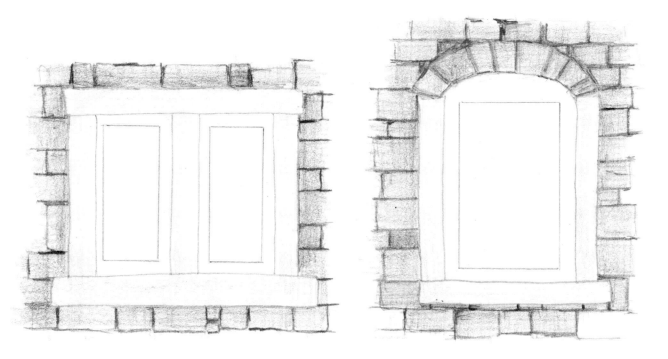

Diagram 17a
The most common window structures
to be found in stone buildings

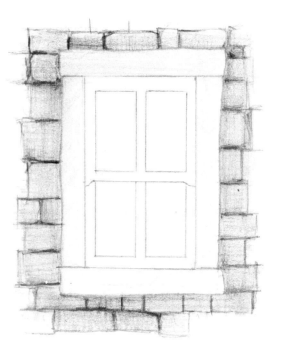

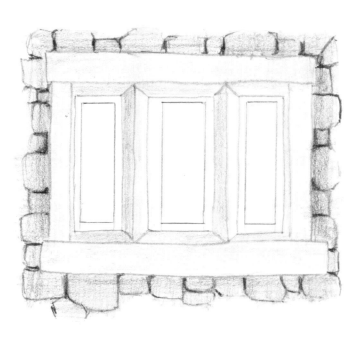

to include the perspective – the windows will be slightly narrower at the furthest end. So, first establish the size and shape of the window frame. Next draw in the shape of the glass sections, leaving the glazing bars to form their own shapes. Finally, shade in the glass according to the strength of the light.

Several patterns of glass exist. A general rule to go by is that the stronger the lighting, the sharper the contrast and the darker the glass – also the lighter the reflections. When a series of small panes is set into a frame, especially if they are pre-1900, the chances are that they will all be set at slightly different angles – not obviously irregular, but irregular enough to reflect light at differing angles, giving an interesting pattern to the whole frame. This is intensified even more with the lead light windows found in Tudor buildings and churches. The diamond-shaped panes catch and reflect the rays of the sun, forming some irregular and absorbing patterns.

For shading glass with pencils, I use a 4B for average lighting and often use a 6B for extremes of lighting when strong contrasts are required. Only ever shade in one direction, generally diagonally. A pure white streak running diagonally across a pane of glass will give a streaked and reflective effect. (Never cross-hatch with reflective objects!) Occasionally shadows will be cast on windows from buildings, trees etc, and these will form their own shapes. If the glass under these conditions looks too dull, brighten it up by simply running the sharp edge of a putty rubber diagonally across the pencilled window. This will have exactly the same 'streaked' effect as the previously described method. For pen drawing, the same

techniques apply, i.e. shading around a light streak. The only difference is that you obviously cannot use the putty rubber trick.

Most window categories fit into either brick or stone walls. **Diagram 17** shows typical window surrounds and the way in which the frames are constructed, the type of inner frame and a look at how they all fit together in one corner.

The Great Fire of London was instrumental in establishing the setting of window frames well into the walls of all buildings. As a move towards fire prevention, legislation was passed requiring that all wooden window frames be set well into the walls, leaving no wood protruding, so that fire could not spread so easily from building to building via exposed timbers. Around this time the concept of sash windows was discovered, allowing for more efficient ventilation and appealing greatly to the Georgian sense of visual 'order'. Consequently, nearly all window frames are set back into brick or stone walls.

The moving parts of the windows into which the glass is set sit inside the main frame, producing an outer and inner frame. The brick or stone surrounds are purely decorative and serve no structural function. They do, however, contribute greatly to the character and visual impact of the particular building.

It is also worth noting here that there will always be some shading on one side of the window frame as the brick surround will create a shadow of some level of intensity according to the direction and strength of the light source.

Care must be taken with windows to ensure that the perspective lines are correct

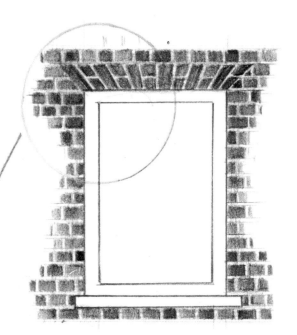

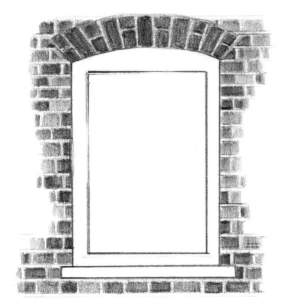

Diagram 17b
The most common window
structures found in traditional
brick buildings.
These diagrams also examine
how wooden window frames
and brick surrounds
fit together

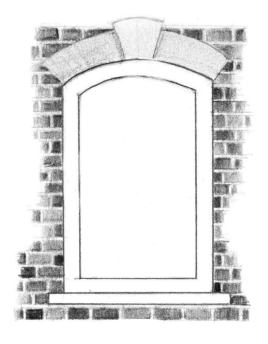

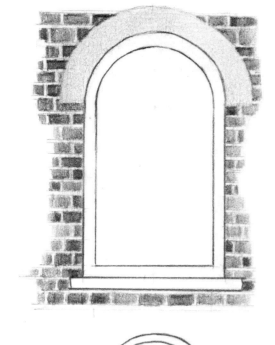

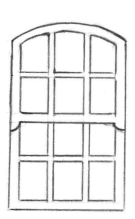

17b

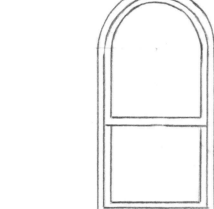

and that the vertical sides are parallel with the sides and edges of the rest of the building. You may see the odd leaning window in timber-framed buildings, but an entire section of the building will lean with it, giving a realistic and feasible look to it. If your window leans in isolation, it will certainly show.

Another important section to examine, or certainly be aware of, is the windowsill. It will always cast a shadow directly underneath. Depending on whichever side the lighting is coming from, the shadow will continue a little to the left or the right. Also, a shadow will settle onto one side of the inner window frame.

All these points go together to make seemingly minor details stand out, and increase the overall three-dimensional look of your building.

Illustration I: Fortesque Lodge, Enfield

This magnificent Georgian lodge is an example of a building that once stood in grand detachment but which has now been built onto on either side, producing some invaluable visual contrasts for the artist.

The frontage of the building is perfectly symmetrical, as you would expect from a house of this era, and is classically proportioned. The white stucco front is also typical, bearing no sign of overt decoration. From the artist's point of view, this allows much scope to emphasize the most striking of visual features – the windows.

Having drafted in the guidelines with an H pencil, I set to work with both 4B and 6B pencils, allowing the odd pane of glass to reflect the light by using much lighter shading. The sash windows are also emphasized by lightly shading underneath the upper sash sections halfway down the window frame. The window ledges are important here. The shadows are directly underneath and slightly to one side of the ledge – once again an exercise in drawing around a shape, allowing it to develop of its own accord.

The pillared door surround requires similar treatment. A white structure set against a white background will stand out only if shadows are used to project the structure forward.

The brightness of the frontage makes it easy to miss the main balancing feature, the roof. The dormer windows set in perfect symmetry are partially hidden by the solid parapet, casting heavy shadows (indicative of the strength of light on a sharp March morning) onto the lighter-than-usual roof tiles.

Being a particularly 'balanced' building, a certain element of visual contrast is important. This can be found in the three levels of height established by the line of the rooftops and in the intensity of the brickwork set next to the whitewashed stucco. The brickwork in the foreground is also a contributory contrasting feature of this picture.

97

Illustration I
Fortesque Lodge, Enfield: This building embodies all the classical late Georgian elements – symmetry, dormer windows, pediments and a simple door surround. The plain stucco fabric allows the windows to dominate the entire composition

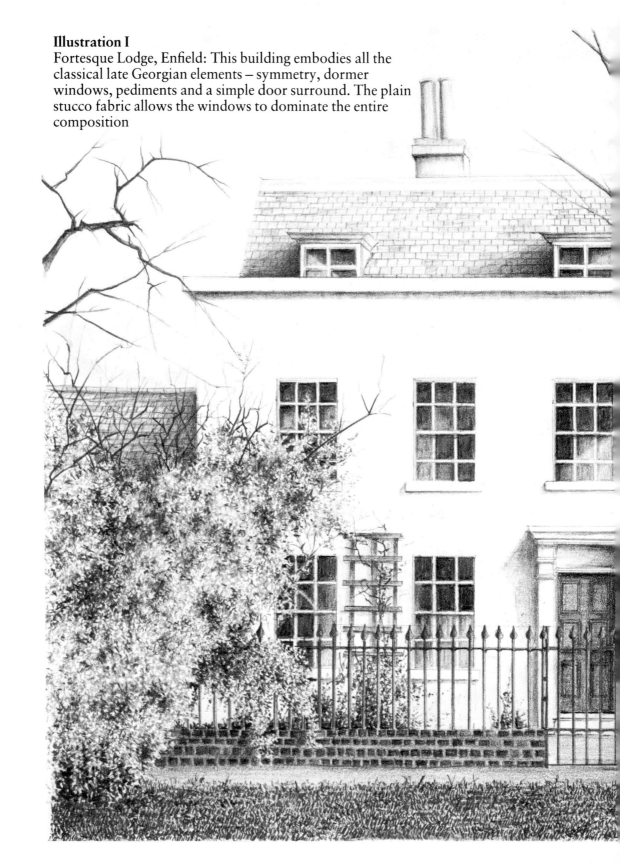

If a window is viewed from an angle, remember to include the perspective.

Shade windows in one direction only – never cross-hatch.

Avoid leaning windows by ensuring that the vertical sides run parallel to those of the building.

9. Doors and Porches

The one certainty that you can guarantee to find somewhere as part of the integral structure of any building is a door, and the frame into which it fits. It might not be where you would expect it, but it will be there somewhere.

Little variety will be found in the shape or fabric of the actual doors; being possibly the most functional of objects, they have never needed to be anything other than a simple shape. So the chief area of interest is often not the door but the doorway itself.

Medieval craftsmen developed a passion for ornamental wood carvings on timber-frames, and many can be found in a well-preserved state throughout older English towns today. Georgian builders' rediscovery of classical and Romanesque ornamentations resulted in some of the most elaborate and ornate door frames you could ever wish to see. This proved to be a major feature of many rural towns where the Georgians built their homes, as opposed to the smaller rural villages which remained the place of the artisans and labourers, whose homes were simple, stark and

functional – but no less attractive to the artist today.

With the exception of the odd Tudor mansion which will often have pointed Gothic or Norman arched doors and door-frames, the majority of secular buildings will have rectangular doors invariably made of wood, with or without windows.

The points to look for that will add greater interest and distinctiveness are knobs, knockers, letter boxes etc, and the glazing on the more modern doors.

The door frames and surrounds require a more studious approach, however. As with windows, the way in which the frame is set into the fabric is an integral part of the structure and is of vital importance. **Diagrams 18** and **19** illustrate some of the more typical doorways with the most appropriate doors (all doors and frames are interchangeable, of course). **Diagram 18** examines the most likely doorways to be found in stone-built houses, whilst **Diagram 19** looks at brick-built houses. The massive stone pillars that surround the door frames warrant some attention here and give a greater

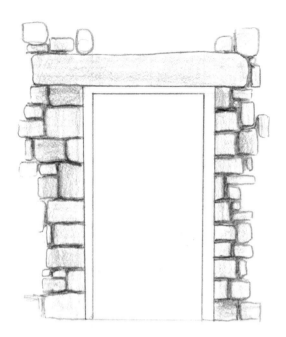

Diagram 18
An assortment of door frames – and fully interchangeable
corresponding doors – likely to be found in stone buildings

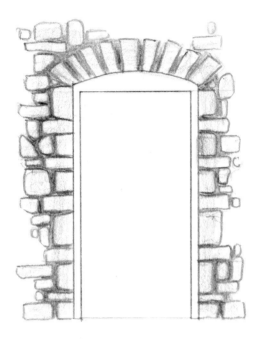

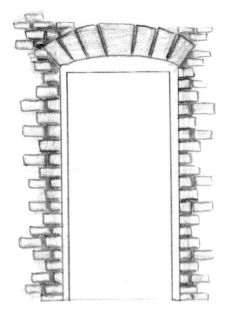

103

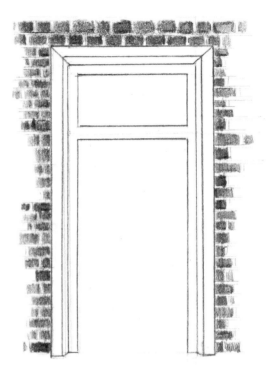 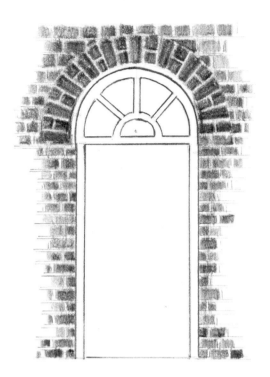

Diagram 19
An assortment of the usual door structures found in brick
buildings with a selection of fully interchangeable
corresponding doors

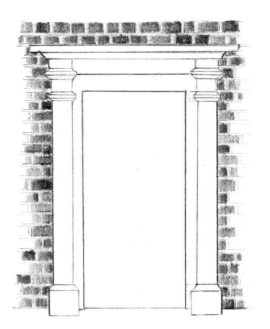

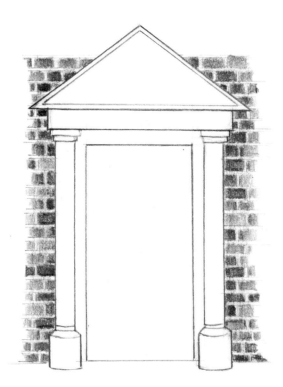

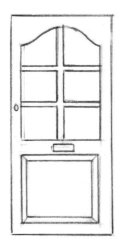

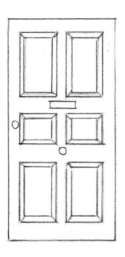

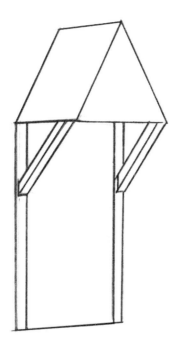 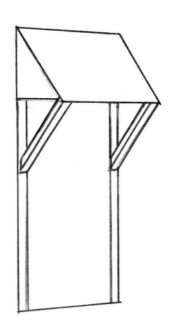 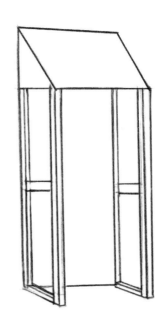

Diagram 20
A selection of 'universal' porches

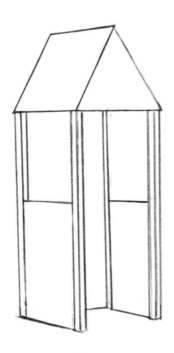 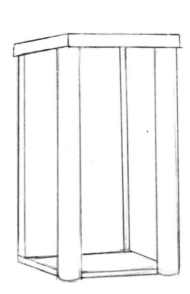

feeling of importance to the timber door frame.

Note that, just as window frames are set into the fabric of the building, so are doorways, and a shadow will fall onto one of the sides and on the top of the inner door frame. Always look carefully for inset structures and their inherent shading. They can make a flat building come alive.

The extended doorway, entrance or porch is a popular feature of English architecture. Having developed initially as a simple method of preventing snows and driving rain entering poorly constructed and badly fitting doors, these have now become both practical and decorative building facets within non-ecclesiastical buildings. (Porches serve an even greater function for churches, but this will be examined in greater depth in Chapter 10.) **Diagram 20** illustrates a broad cross-section of the most common types of porches you are likely to find on any drawing expedition. All can be drawn using a box construction for the basic guidelines.

At their simplest, doors are flat pieces of wood that require no guidelines or special formulas for drawing. At their most complex, they can be well-glazed ornaments, surrounded by plaster porches, which cast intricate shadows onto the building's walls. Note that doors will often be darker than the fabric of the walls, but apart from this the only real advice is to look for the details, as they contribute so much to any building by asserting its own individuality.

Illustration J: Forty Hall, Enfield

Forty Hall is a fine example of the small mansion. Among its most visually striking features are the size and scale of the windows, considerably increased by the plain plaster surrounds. These, in turn are intensified by their contrast with the brickwork. The central stack of large windows with pillared surrounds is reminiscent of the Romans' classical style of ornamentation – and note the (Greek) Doric columns. The ornamental posts on the edge of the terrace steps also add to the overall 'classical' effect and atmosphere.

The numerous chimney-stacks are also of interest. Set in groups of four on the main building, they may appear 'top heavy'. The roof, however, is well capable of taking the weight — only the composition feels the pressure.

The decorated pedaments and the decorative lines that run horizontally across the building cast some important shadows, preventing the mansion from looking 'flat'.

Finally, whilst this building may lack some of the 'hotch-potch' structures and overgrowth that create the atmosphere surrounding many rural buildings, Forty Hall has a charm of its own. The inclusion of the closely cut lawn makes it easier to imagine the Georgian garden parties, and the estate workers gathering at Christmas to collect their gifts of fowl (from the back door, of course) from the Lord. Foregrounds are always important and can help to 'set the scene' and create the atmosphere that you want to surround your building. After all, buildings are only made of inanimate fabrics. It is the surroundings and lighting that will inject the 'life' of your picture.

Illustration J
Forty Hall, Enfield: A grand, imposing building that was surprisingly easy to draw due to its simple geometric linear structure

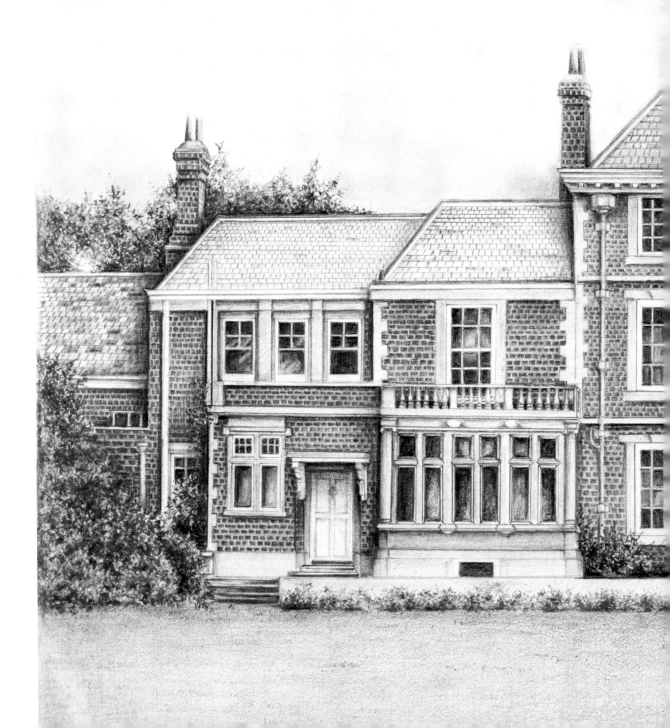

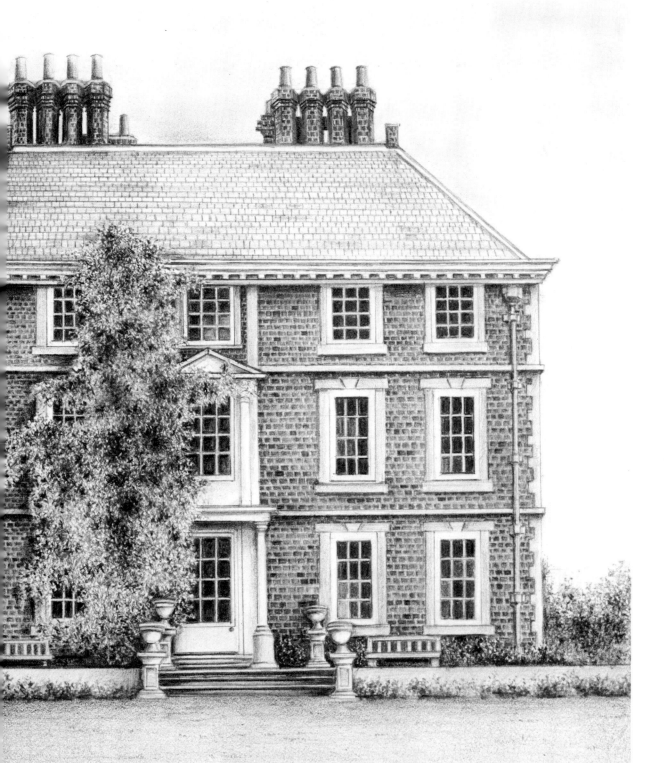

10. Churches

The study of English parish churches from the point of view of social development, historical architecture and drawing could well be a separate study. Here I offer just a few basic pointers.

The term 'parish' evolved from a Latin word, *parochia*, meaning 'a big region like a province', or 'a collection of believers of the same race'; so parish churches served a definite area, or rather the people living in that area.

As the population of Anglo-Saxon England grew and villages developed, many small wooden churches were built for use by the villagers. As these churches were invariably built by the lord of the manor, on his own land, they were, more often than not, close to the manor house. Not only did they become the geographical centre of the village, they also became the working centre. The surrounding forest land needed to be cleared for building-materials; local people were employed in the construction of the church (masons, carpenters etc), and much civil business was executed outside the church doors, or in the porchway, as a period of commercial growth developed. Side porch entrances were much favoured by English church-builders – both to keep the weather out and as a place for conducting non-ecclesiastical business. Rural life was evolving with many activities centring around the church building.

In the post-Norman invasion period many new churches were built and for the first time in English architecture towers began to develop. Whilst they were of great symbolic importance, as they represented the Church as the link between Heaven and Earth, they introduced many new structural problems. (The solutions to these were eventually discovered and are now vital to the many visual facets of churches that are so absorbing to draw.)

Towers were difficult to build, especially for the local village craftsmen who lacked the experience of building on more than one floor. Consequently, elaborate methods had to be adopted to prop them up – for example, buttresses helped to absorb the thrust from the increasingly sized walls. These were initially additional columns

built against the walls to support them, but as architectural knowledge became more scientific they became more strategically positioned at the points of great stress. The early English church-builders, however, relied on their limited experience and guesswork to decide where to position these supports. The one thing that they did understand was that the further the buttress from the wall, the greater its support – a point to note perhaps when drawing the larger ones. (See **Diagram 21**.)

Many windows were built in towers, to reduce their weight, which introduced further new features. These windows were always fully glazed, as patrons of ecclesiastical buildings were generous – building a church was one way of ensuring a life eternal.

The easily recognizable round-headed Norman arches eventually developed into the significant Gothic-style pointed arches, of a much sounder construction, supporting thrusts from above and from the side so much better. These are also considerably easier to draw, as you will always have a centre point from which to establish your symmetry. This is considerably easier than guessing where the centre of a semicircle is.

After 1200 England was in a state of increasing prosperity. More stonemasons were employed on church construction, injecting their ever-developing skills into the elaborate decorations and carvings which were to mark a distinctive period. The triple lancet window became a major feature, one which is both challenging and enjoyable to draw. (See **Diagram 22**.)

As window tracery developed as a witness to the stonemason's art, so the development of the spire bore witness to the increasing technical knowledge of the early English builders. These spires were, perhaps, the ultimate achievement of the English Perpendicular-style architects and formed an important visual aspect of the landscape. They became the symbols of local pride, reflecting the expertise of local craftsmen with their local materials, and also became an important landmark for travellers. Some of the country's most notable spires appear with great regularity in eighteenth-century paintings and prints. Even the more notable of English painters, Constable and Turner, made use of them in their work.

With the development of these octagonal tapering spires set onto square towers came the addition of pinnacles and the introduction of 'flying buttresses'. (This is where it starts to become complicated for the artist – so many bits and pieces to line up and shade!) These were the logical development from the standard buttresses, taking the form of an extended, often arched support, strengthening the structure and counteracting the outward thrusts. Apart from being an integral part of the church structure, the flying buttress also allowed stonemasons to exhibit their carving skills, and they developed what are often mini-sculptures in their own right.

From the late Middle Ages onwards, a new classical style developed, becoming manifest in the 'temple-like' churches of the larger towns. As the Reformation resulted in a proliferation of non-Anglican denominations, many 'chapels' were also erected – though the majority were so small and cheaply built that they have not survived. The sober exteriors of the Georgian church-

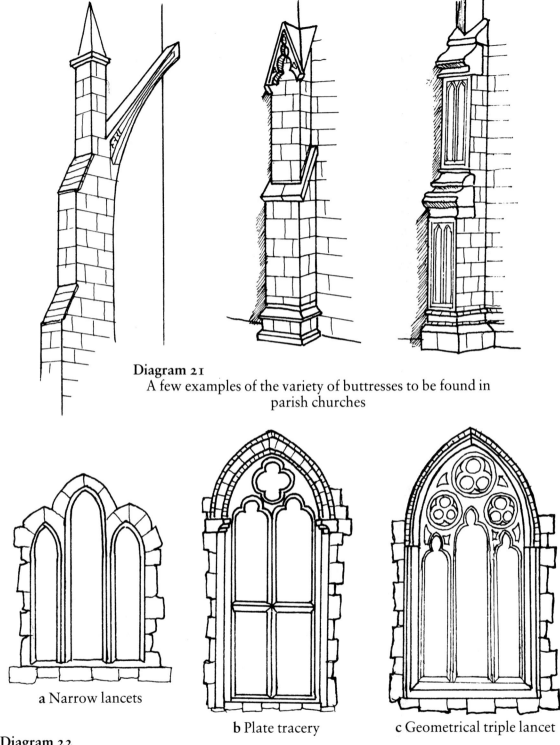

Diagram 21
A few examples of the variety of buttresses to be found in parish churches

a Narrow lancets

b Plate tracery

c Geometrical triple lancet

Diagram 22
The most commonly found windows in parish churches

builders marked the end of an era of ecclesiastical building.

Few churches can be attributed to any one specific period. Nearly all English churches, big or small, encompass hundreds of years of Christian history as generation after generation has built onto the central structure either as an extension to cope with the development or growth of a village or town or, as is more common, by way of restoration.

Now to look at some specific points for drawing parish churches. As shown in **Diagram 23**, churches, like most buildings, can be drawn through the process of box construction. In terms of technique, it is vital to appreciate that the perspective at the top of the tower will be greatly increased, giving a more pronounced effect of height. Another vital tip regarding the top of the tower is that from the ground you will be able to see neither the roof nor the area onto which the spire is joined. This will invariably be surrounded by a pediment which may well be attractively carved and which could warrant looking at carefully.

The buttresses illustrated in **Diagram 21** that invariably surround towers can also be drawn by using the box construction method. Having drawn in the tower or wall, a section of long, thin boxes can be built up around this, with each box being smaller than the previous as you work your way up to the roof.

The vast majority of spires are octagonal, only four sides being visible at any one time. (Developing the skills to shade these eases the way for the next section on windmills and oasthouses, as graduated shading is required for all of these structures.) As all the eight faces on an octagonal spire are flat, the graduated toning can be kept within firm limits, with each section becoming darker as you look across the faces visible to you, according to the strength and direction of light.

The stone carving and tracery in church windows can often look most impressive on the inside with the atmospheric light beaming through the stained glass. They can also look quite dull, although gloriously decorative, from the outside. This is one occasion where the glazing bars will more frequently be drawn onto the glass, making the lead appear darker. Again the odd glass section will be shaded darker – but, as always, draw what you see.

The general fabric of the building will always be dominated by local materials. Whilst most churches are built of stone, wooden towers can still be found in some older villages, and a combination of wood and stone is not unusual.

Finally, roofs are often completely out of view from close up on the ground, hidden by the assortment of structures surrounding the main 'block'. When they are visible, they are generally covered with lead, making the roof frequently appear darker than the stone building.

Churches will be found in every village and town throughout England. They often defy positive categorizing, as so many additions have been built on throughout the years — but this makes them all the more absorbing and exciting to draw. Whilst they are higher than the majority of rural buildings you are likely to come across, this is rarely a problem, as most churches are surrounded by open land (albeit generally in the form of a graveyard), allowing you to

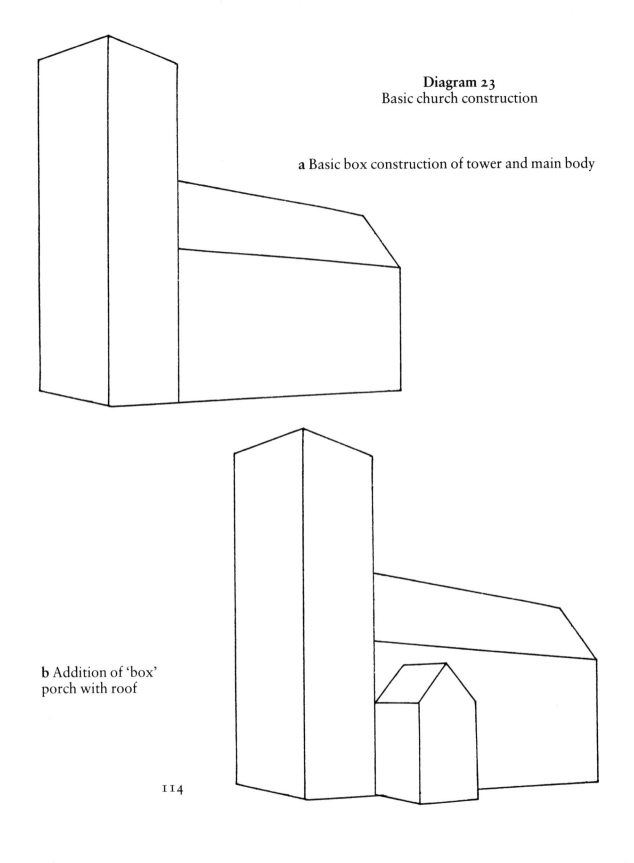

Diagram 23
Basic church construction

a Basic box construction of tower and main body

b Addition of 'box' porch with roof

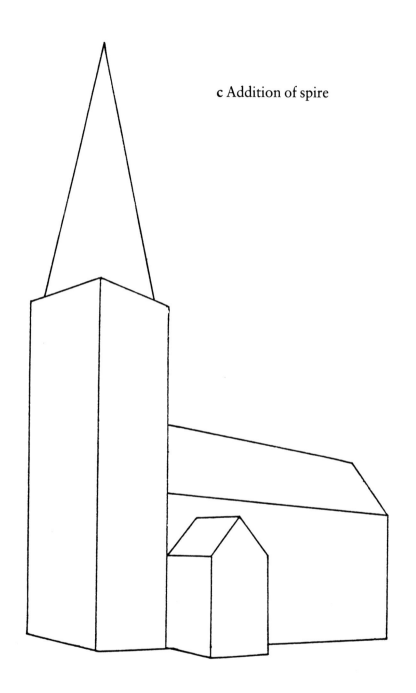

c Addition of spire

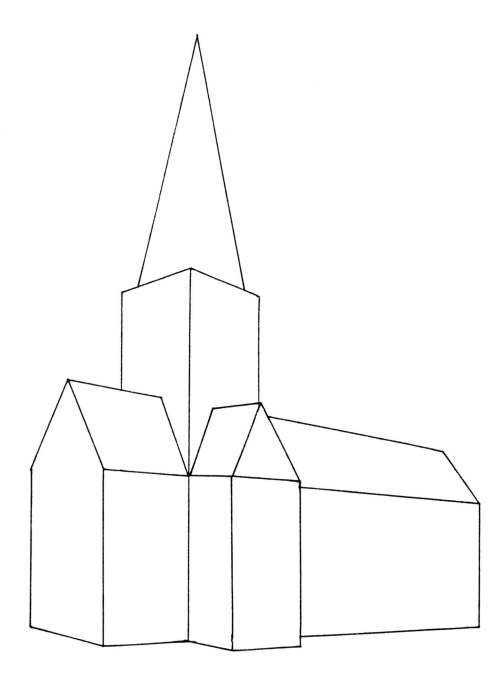

23d Many churches have been expanded during their history –
'box' construction allows these additions to be drawn
without too much difficulty

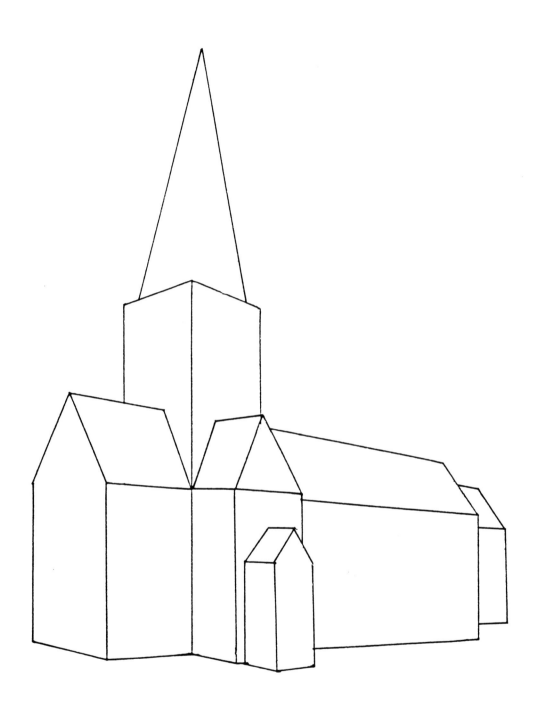

23e The grandest and most elaborate churches have their
origins in very simple 'box' construction

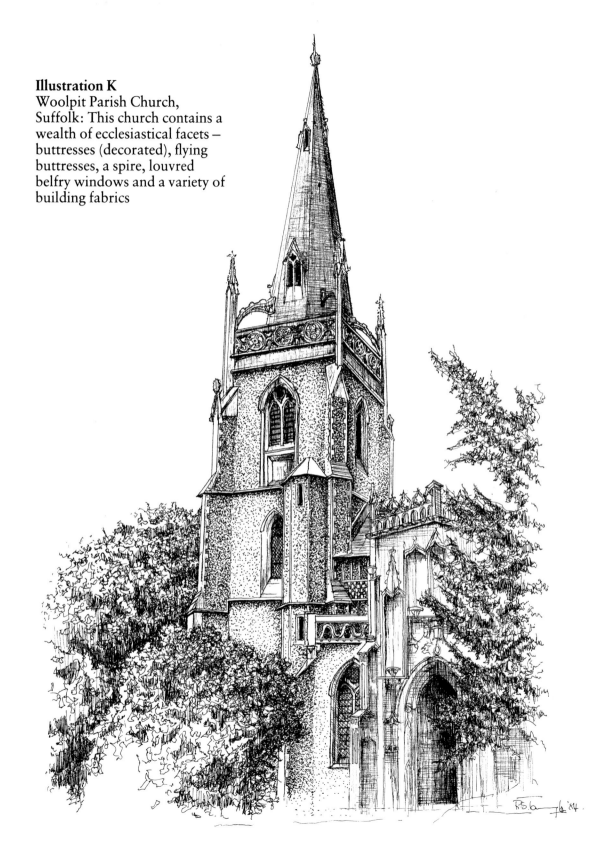

Illustration K
Woolpit Parish Church,
Suffolk: This church contains a
wealth of ecclesiastical facets –
buttresses (decorated), flying
buttresses, a spire, louvred
belfry windows and a variety of
building fabrics

stand or sit well back and to take in the church's scale and charm.

If you are going to spend a long time drawing or sketching in a churchyard, it is perhaps courteous to inform the vicar or rector (you do not need to ask permission though) so that he can advise you of any ceremonies or activities at which your presence might not be appreciated.

Illustration K: Woolpit Parish Church, Suffolk

The parish church of Woolpit is typical of the thousands of parish churches to be found throughout England. It is a magnificent example of the simple English Perpendicular style of architecture. The spire certainly does stand out and can be seen for many miles across the rolling Suffolk countryside. The simply decorated buttresses accentuate the height, leading to four simple flying buttresses supporting the octagonal tower. The Gothic pointed windows are also typical of the triple lancet stone tracery so popular with the stonemasons of the late Middle Ages. Interestingly enough, the decorative carvings on and around the porch contrast with the simplicity of the tower, suggesting that the porch is a much later addition, built at a time of greater skill and prosperity.

The rough texture of the tower is recreated here by using a stippling technique, better done by a pen than a pencil (pencils need constant sharpening and the size and tone of the dot will vary considerably). It involves constant 'dotting' across the area to be covered with the tip of the pen; the deeper the shading, the closer the dots, increasing the visual intensity.

The spire, being much smoother than the tower (also suggesting that this too was a later addition), requires a different shading technique. The method of straight-line shading in the direction of the tower faces seems appropriate here, with only a few downward strokes to introduce a slight element of cross-hatching.

Louvred windows are frequently found in the belfry areas of towers and are drawn using the same method as that of drawing weatherboarding. The lower stained glass windows are drawn with the glazing bars considerably darker than the actual glass – a common feature to be considered when drawing churches from the outside.

The peace and tranquillity to be found in Woolpit churchyard are therapeutic, and the lighting, atmosphere, foliage and surrounding ground change with the seasons, making this scene a constant joy and challenge to draw.

Most churches can be drawn using the simple box-construction method.

Appreciate that when drawing churches the perspective at the top of the tower will be greatly increased, giving a more pronounced effect of height.

11. Working Buildings

One of the most magnificent sights to be seen from Lincolnshire to the Anglian Fens is that of a gleaming white weatherboarded windmill towering above the skyline. Once the mills were socially and historically almost as significant as the church spires mentioned in the previous chapter.

Before the start of the decline of the miller's trade in the 1890s, thousands of small, medium and positively grand windmills could be seen at work throughout the country. Millers were proud of their wealth and consequent standing in the community, which was reflected in the splendour of their windmills, until steam-driven flourmills replaced the traditional windmills and the introduction of electricity finally brought about the demise of most working mills, left to become derelict shells or ruins. Fortunately, many people recognized the potential beauty of these skeletal wrecks and embarked on a vigorous conservation programme throughout the country.

Whilst it would be illogical to expect industrial or working buildings to be constructed of anything other than the obvious local materials, windmills more than many other structures seem to embody local traditions in every respect. Certain key types do exist, however, and can be examined in more depth. The two main types – either free standing or built onto a brick base generally called a 'roundhouse' – can be usefully sub-divided into post mills (**Diagram 24a**), towermills (**24b**) and smockmills (**24c**).

Basically, free-standing mills are fixed very firmly to the ground! Postmills derive their name from the central post on which the whole structure is pivoted, enabling the mill to be turned physically into the wind. The brick (or occasionally wooden) roundhouse on which the mill structures were built extended upwards into the underside of the mill, surrounding the trestle, protecting the timbers and providing extra storage space for the miller. These roundhouses also raised the height of the mill, lifting the sails higher into the air and the stronger winds.

The later towermills had a cap added to

120

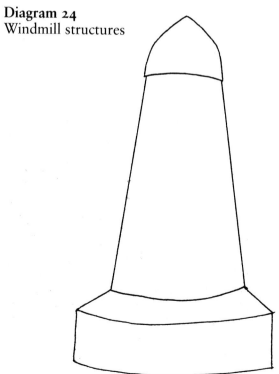

a Postmills –
with roundhouse and free standing

Diagram 24
Windmill structures

b Towermills –
with roundhouse and free standing

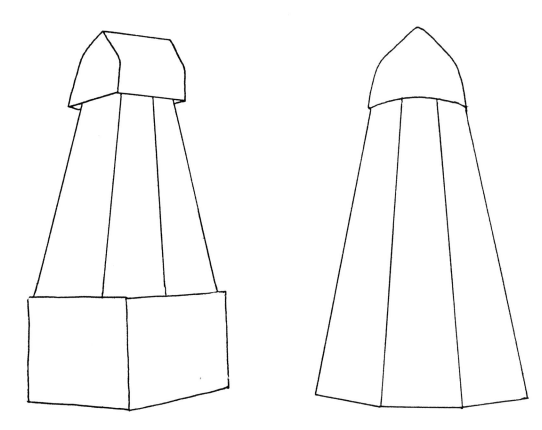

24c Smockmills – with base and free standing

the top containing the sails and driving-shaft which enabled only the top section to move into the wind. Many of these later mills were built of brick, were generally round and were often five or six floors high. Smockmills are frequently hexagonal and were often built of timber (see Chapter 5).

The windmill sails were built around a pair of central stocks which resemble an aeroplane propellor (see **Diagram 25a**). Despite the odd visual appearance of windmill sails set at an angle, always remember that all four sails are set on the same side of the central cross shape. Again, many variations exist on the actual sail structure. Three of the main types that can be identified are shown in **Diagram 25b**.

Simple windmill shapes are easy, but always fun to draw

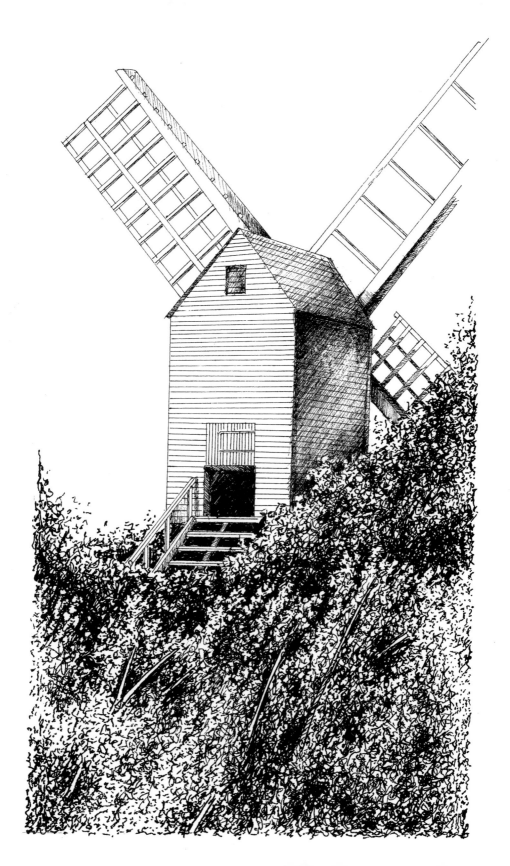

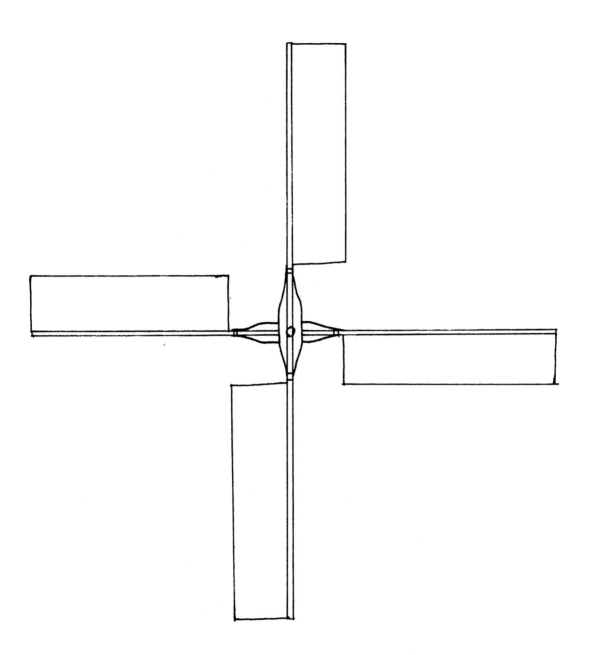

Diagram 25

a Standard windmill sail shape – note the aeroplane propellor
shape of the shafts

124

b A few examples of standard windmill sail 'skeletons'

Diagram 26

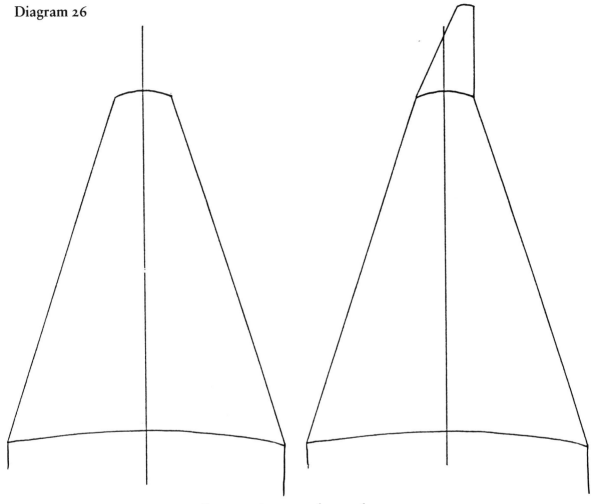

a Construction stage for oasthouses

OASTHOUSES
Another type of rural working building you are likely to find is the brick oasthouse of the Kent hopfields. It shares the drawing methods required to construct the round-houses of the postmills and the towermills and is worthwhile considering here.

As shown in **Diagram 26**, start with a line drawn straight through the centre from base to apex, which will help attain the symmetry required; the shading on the curved surface will be graduated, fanning out towards the base.

The conical caps found on top of the oasthoue stacks will always lean to one side as they are themselves directional. This can often create an optical illusion, suggesting that the whole structure is not symmetrical.

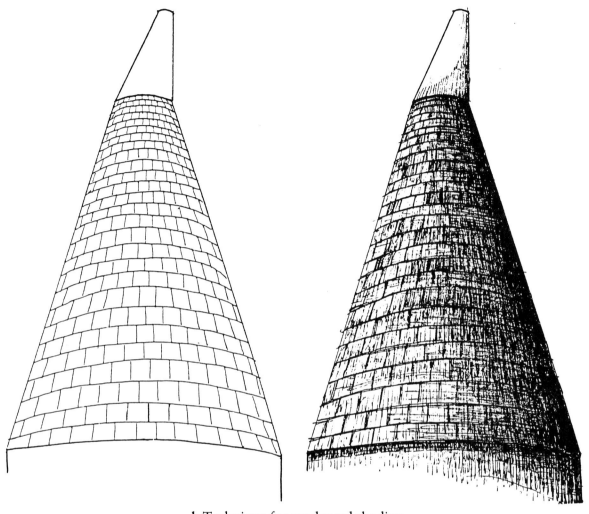

b Technique for graduated shading

Do not be fooled! It is! So always ensure that you draw the brick structures first, then add the cap.

Note that working buildings – or, more to the point, buildings that once worked – will generally be found on the edge of towns and villages. Unlike churches and large manor houses, rural working buildings often grew around the village rather than being the centre of development. Consequently, they will often be studied in their own right and not necessarily as part of a townscape or village composition. Rarely are these buildings in pristine condition or still have a working atmosphere about them.

Illustration L
Hornchurch Mill, Essex: This lovely old mill no longer
stands, but in its time it provided some wonderful visual
information for a composition. The derelict appearance is
enhanced by the broken sail, the 'patched-up' shed and the
old abandoned cartwheel

Illustration L: Hornchurch Mill, Essex

Hornchurch Mill has suffered the fate of many windmills and sadly no longer stands.

It was, in its heyday, a medium-sized post-mill on a warm red brick roundhouse. The postmill itself was weatherboarded and required some accurate drawing, ensuring that the lines of the wooden planks converged slightly as they ran from top to bottom. The shading on the circular posthouse is, as always, graduated using downward pen strokes fading in intensity towards the light source.

The sails are also worth noting here. Their stocks form straight lines running from top to bottom, although this may not appear to be the case. The sails often appear 'weighted', suggesting some form of irregular balance – remember the analogy between the windmill sails and the aeroplane propellor.

The barn standing next to the mill is very much part of the composition. The wooden planking and supports are either crooked or missing, adding to the sense of 'rural charm'. The missing tiles also add an element of variety and contrast to an otherwise uninteresting mass of straight lines.

The neglected cartwheel leaning against the side of the barn wall acts as an ornamental addition as well as serving to break up the monotony of the dark shading that falls against the wall. These are always important things to look for when considering buildings in the context of the overall composition.

The foliage is also important here. The overgrown and wild brush adds to the mood of this picture. The 'rural rusticity' of the composition comes from the overall tumbledown and overgrown appearance – always endearing qualities to the artist.

Illustration M: Saxstead Mill, Suffolk

Saxstead Mill is one of the few mills standing today that are capable of working. It is very similar to Hornchurch Mill in that they are (or were) both postmills positioned on brick roundhouses.

This is a slightly unusual composition as the building is positioned in the 'middle ground', as opposed to the foreground, but the foreground is still very important. The shimmering effect of a balmy midsummer's day is achieved by a dual process: initially, the wheatfield was drawn using a series of very fine lines, leaving the tops of wheatstalks as light as possible, creating a cascade effect as they sway gently in the breeze; secondly, the stalks are all drawn leaning slightly to one side, again suggesting movement. The full impact of the lightness of the wheatfield is heightened by the depth of tone in the background trees – a classic case of the background pushing the foreground forward.

Finally, the sails have a slight twist to them, giving a somewhat irregular visual appearance but, I believe, very good for catching wind and increasing the effectiveness of this grand mill considerably.

Illustration M
Saxstead Mill, Suffolk: An unusual view of this well-preserved mill. The foliage in the middle and foreground add to the rural atmosphere

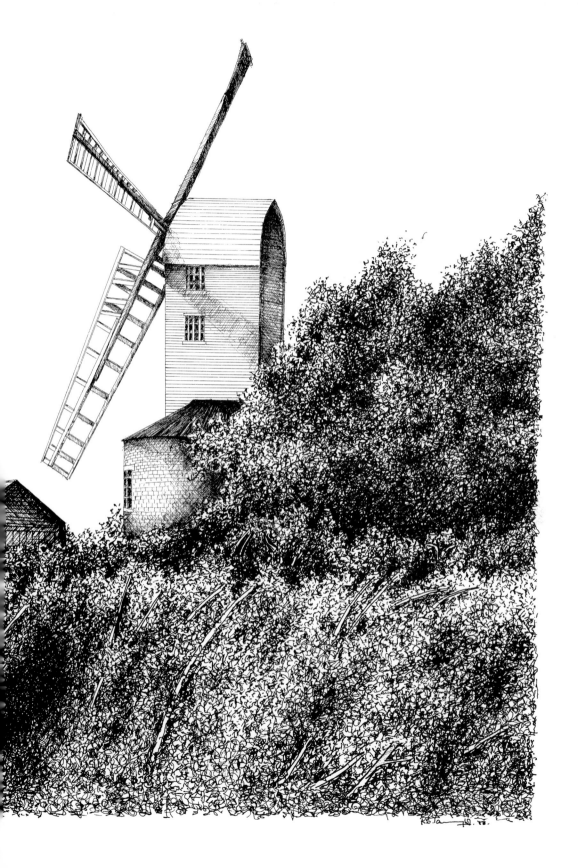

'The Maltings', Thorpe-le-Soken, Essex: A fine example of
Victorian industrial buildings developing an element of rustic
charm as the bushes and weeds begin to grow. Note the
typical Essex weatherboarding

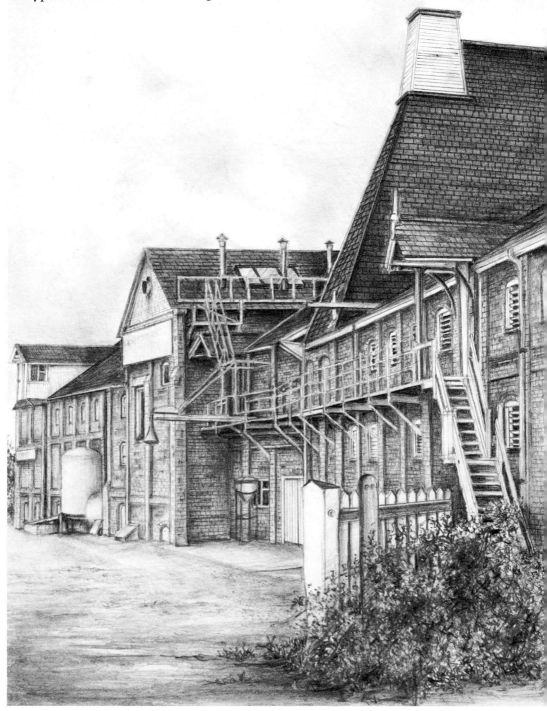

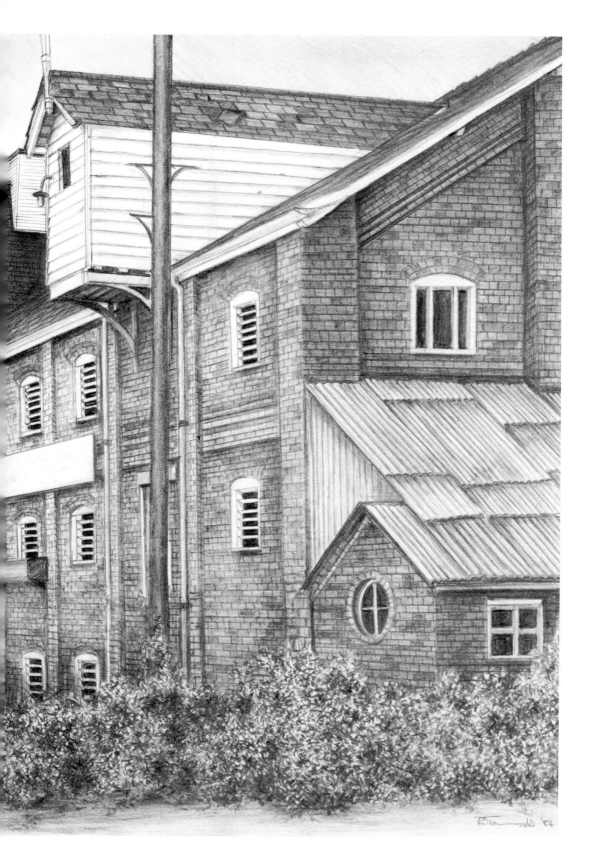

Illustration N: The Maltings, Thorpe-le-Soken, Essex

This fascinating building is still in use today as a 'maltings' – this is evident by the state of repair of items such as the steps and the walkways.

Perhaps the two most interesting features of this composition are the intensity of the perspective and the complexity of the details.

The pitch of the main roof is counteracted by the visual upward thrust of the tiled industrial chimney stacks, making a solid break in the perspective lines. (Note the unusual weatherboarding on the chimney-stacks.)

The intensity of the perspective had to be established initially with a series of guide-lines (using an H-grade pencil) on three levels: first, the top and bottom converging lines for the main body of the building; second, the top line of windows, and third the bottom line of windows, allowing the middle-range windows to follow an obvious course of their own. All the other details, including the walkway and the brick courses, could fit in with this simple per-spective grid.

Another interesting factor is the wealth of absorbing detail in every section or corner of this immense building. Pipes, steps and sup-ports seem to run horizontally along and across the front of the building, visually counteracting the straight brick pillars.

These occasionally merge with the white of the louvred windows, which themselves form an interesting 'visual line' spanning the length of the building.

Another area of real interest to the artist is the corrugated iron roof in the foreground. The material is broken up and fitted together in a 'hotch-potch' manner, giving a slightly 'old and rural' feel to the composi-tion, contrasting with the stark Victorian frontage of the maltings.

This building is typical of many found throughout England, either active or reflect-ing an aspect of past rural industry. Some very challenging buildings can be found sur-rounded by redundant junk and machinery, covered with overgrown creepers, weeds and foliage – proving that the buildings worth drawing are not always to be found in the picturesque thatched villages.

Illustration O: Crane's Millpond, Braintree, Essex

This is a purely functional set of buildings not terribly decorative within themselves – it is much more the setting that makes this an appealing composition. The vast amount (and variety) of surrounding foliage made this scene hard to draw. The moving water also proved an interesting challenge. The technique for drawing moving water in pen and ink is exactly the same as with pencil (see **Illustration F**), i.e. leaving the white paper white by shading with straight lines behind these sections. Obviously the fastest-moving water at the top of the 'falls' will be the whitest of all.

The foliage is built up by the use of two techniques that fit well together, a combination of 'stippling' and the 'scribbling' method (see p. 142) which deals specifically with such peripheral compositional facets. The leaves in the foreground are also drawn by methods described in Chapter 10: the shapes of the particular leaves are drawn in first, either hanging downwards or projecting upwards, as the case may be, and then shaded in between the leaf shapes, allowing them to stand out.

This type of scene, whilst not concentrating on any actual building, is appealing as it is more of 'a landscape with a building in it' – an alternative way of looking at pictures perhaps!

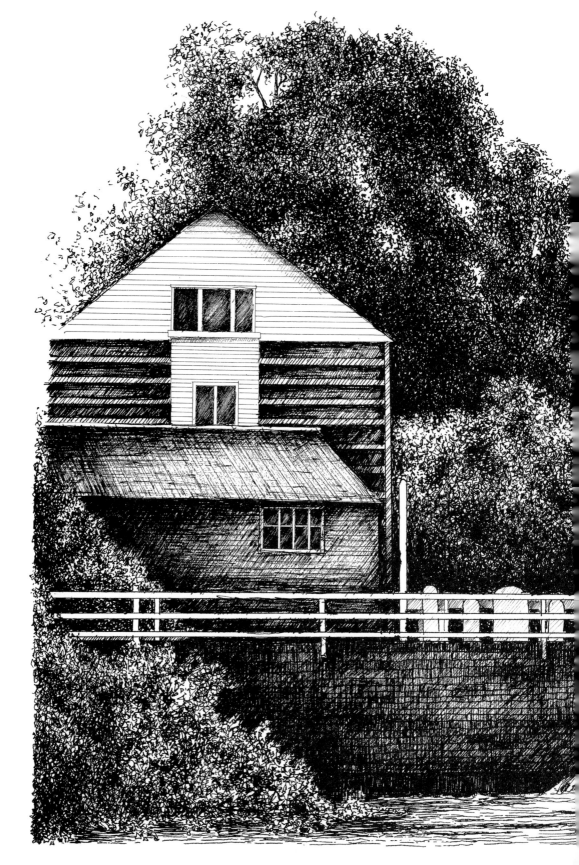

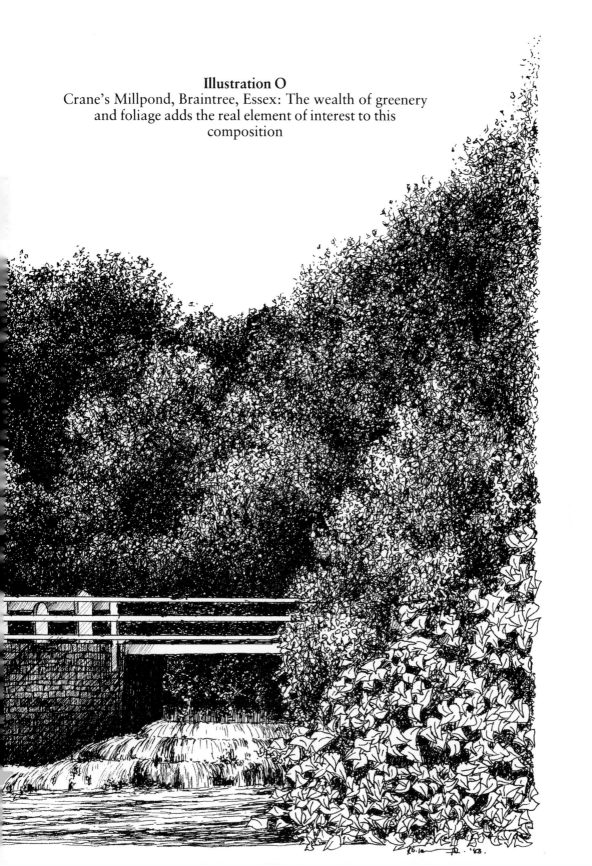

Illustration O
Crane's Millpond, Braintree, Essex: The wealth of greenery
and foliage adds the real element of interest to this
composition

12. Finishing Touches: Details and Presentation

DETAILS

Among the most important considerations when drawing buildings are the peripheral bits and pieces that surround your building(s). The beauty of this part of the composition is that you alone decide exactly how much detail you put into your drawing and determine the eventual level of finish to which you take your own picture, which will, in itself, begin to develop as a recognizable personal style. Attention to details gives your drawing an element of originality and identity.

You will find all types of similar houses anywhere in any village or town throughout the country. It will, consequently, be more than just the size, shape, fabric and visual line that you should look to for some form of identity. The coachlamps outside the porch, the whitewashed fence or the wrought-iron railings can add a sense of personal identity to your drawings and can also help to 'liven up' the front of your composition, which can easily become lost in the grey mass of pavements or roads that frequently occupies the foregrounds of

landscapes.

Fences, gates and railings are the most likely foregrounds that you will draw, and it is worth spending some time examining the best methods of fitting these objects into your composition. Where these objects are darker than the building, it is considerably easier to draw them than when the fences etc are lighter. The effect, however, is far less exciting. Visually, we expect to see darker objects drawn onto light backgrounds – the reason why we nearly always draw in black on white paper. Consequently, when we see this reversed, with light objects set against dark backgrounds, the visual effect is often quite a shock.

To cope with whitewashed fences and gates we must briefly return to Chapter 3. Your composition must be treated as a whole and as one single unit – not as a group of separate units that will hopefully fit together when you have finished – the chances are they won't! If the fence is drawn in at the beginning with the rest of the composition, you will not go far wrong. All

Diagram 27
Peripheral details: (i) 'Negative' shapes are established by
drawing behind the shapes.
(ii) Allow the paper to work for itself

you have to do is to draw in the brickwork or foliage behind it, leaving the white untouched to develop almost a life of its own (see **Diagram 27**). The fence will appear in 'negative' form as the most visually outstanding section, being pushed forward by the depth of the tone behind it. The final stage will be to use the edge of a putty rubber to 'touch out' the smudges that will invariably now cover the white sections. Do try not to rest your hand on sections of paper you intend to leave white, as marks are very easily transferred from one section of the picture to another via the edge of your palm.

Whilst it can never be claimed (fortunately) that cities and large towns are devoid of trees, bushes and foliage, they are generally formally planned and ordered. In the more rural environment they tend to grow in their own directions and with greater spontaneity. The overgrown garden and the well-trained ivy make a welcome break set against a solid brick background. The smell of honeysuckle on a warm summer's evening is an immensely enticing atmosphere in which to sit and relax with a sketch-pad and pencil.

Few hard-and-fast rules exist for drawing the great tangles of greenery to be found growing on or around buildings – only, to pick out a few positively identifiable leaf shapes in the foreground of the foliage you are drawing. The depth of shading behind these leaves will determine how much they stand out from the rest of the picture. The same principle applies to drawing trees. To bring out the shapes of a few distinctive hanging leaves, shade behind them with a series of dark cross-hatched strokes. The shapes and sizes of trees can also be altered

slightly to fit the composition.

If you want to create a purely photographic image, take a photograph. Use your drawing and sketching skills to create a *unique* image. Capture the shapes and textures, and allow your composition to breathe and to develop a life of its own.

Illustration P: Pub Doorway, Preston, Lancashire

This public house doorway could be found in any town or village – in fact, it is probably very easy to find quite a few in every town and village!

The key to this drawing is the variety of tones and even textures in the assortment of glass panes.

As usual, the glazing bars are still lighter than the glass panes – the chief difference with pubs is that the shapes of the panes are often curved, pear-shaped or circular. But by far the most demanding parts are the etched windows. The light grey tones of the glass with the even lighter etched patterns are difficult on flat glass, and considerably more demanding when the glass is curved. This is one of the rare cases when an H-grade pencil comes in useful for shading. Having sketched the etched designs as lightly as possible, I used the H pencil to shade around these, allowing them to stand out – to avoid the shapes being pure white, a slight degree of shading was used on them. The problem of symmetry was overcome by 'lining up' both sides at the sketching stage before starting to draw in detail – an important rule for any piece of work.

The hanging baskets consist of a vast mass of cross-hatched foliage with a few distinctive leaf/flower shapes being visually

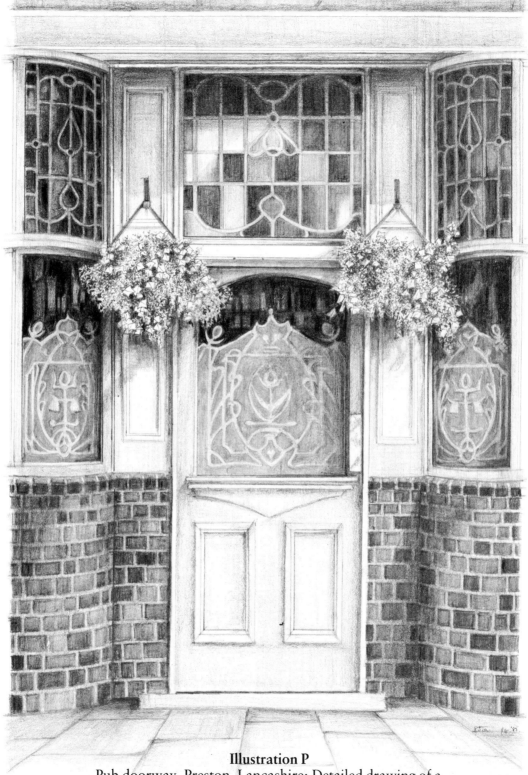

Illustration P
Pub doorway, Preston, Lancashire: Detailed drawing of a
small section of a building can be equally rewarding.

pushed to the foreground by their lightness in contrast to the dark shading behind them. The entire contents of the basket are themselves made to appear lighter by the shading on the wooden panels behind them, as is the case of the dark glass behind the etched glass 'pushing' the lighter glass forward.

Illustration Q: Victoria Pump, Woolpit

The purpose of this picture was not solely to record the pump housing but to draw one particular section of a village scene, including the village green, the surrounding trees and the row of cottages running alongside. As rural buildings rarely stand in total isolation, it is a good exercise to practise looking at an entire 'scene'.

A few points on drawing-technique are worth noting here. The 'witch's hat' roof on the pump housing has been drawn using graduated shading (as is used on oast-houses), working from left to right across the curve.

A slight difference is highlighted here between pen-and-ink and pencil techniques when it comes to drawing the grass surrounding the pump. Too much detail on the grass would make the composition appear 'bottom heavy', detracting from the centre of interest – the pump. So a technique of 'suggestion' has been used, picking on a few clumps carefully selected to create a sense of visual balance and sketching them in with a few quick, yet confident pen strokes.

Finally, I made a conscious decision to 'enhance' the composition with the trees on one side. The leaves, as always, have been drawn by selecting a few correctly shaped ones and shading behind them. I have also adopted the technique here of drawing a selection of 'hanging' leaves that are not attached to any obvious twigs or branches. This is purely for effect and gives an almost 'weightless' feel to the leaves: they could be falling with the first cold winds of autumn or shimmering in a gentle summer breeze – the choice is yours.

PRESENTATION

As you become more competent with your building drawings, a few commissions may start to come your way, and requests for your services as an illustrator. Parish magazines, school PTAs, art clubs and assorted charitable organizations will always welcome your services with open arms. So, be prepared. The following points are, therefore, worth mentioning.

Pencil drawings can be reproduced, but the grey tones will diminish considerably as the additional process of 'screening' is carried out. This process involves laying a screen onto the drawing, breaking down the image to a series of tiny dots, before it is made into a lithograph plate – a complex and relatively expensive process. Neither will pencil reproduce well on a photocopier. Pen-and-ink is by far the most suitable medium for reproduction in print (lithograph processes or photocopiers) as the plain black and white will register sharply with any of the assorted reprographic processes. Any printer will be able to enlarge or reduce your work to your requirements (in fact, many photocopiers have this facility now). So you must know exactly what your requirements are. Most drawings will look better in reduction. The lines and shadows are intensified and make many people wonder at your skill. Always check with the

clients and establish exactly what size they require the finished artwork to be, and make sure that your work (twice the size is quite acceptable) will reduce to the correct proportions. Most printers will gladly help you with this aspect of illustration.

Also, people are always proud of their properties, especially the more picturesque, and will gladly welcome a picture of their home to hang on their walls. So it will be of value to examine methods of visual presentation.

Basically, there are three ways of presenting drawings: with a card mount and frame; with just a frame (often more suitable for larger works), and with a 'clip mount' – that is, a card mount covered by a sheet of glass held by clips.

Putting a card mount around a drawing will serve two purposes. Initially it will increase the overall size of the finished picture. Secondly, it will play a visual trick, focusing attention on the actual drawing. This raises the important issue of coloured mounts for monochrome drawings. Strong colour in a card mount can easily 'kill' a pencil or pen drawing by making the mount the main attraction, diverting the viewer's attention from the drawing.

For pencil drawings, which invariably contain a wide range of grey tones with only a few pure blacks, I tend to use a white or a pale cream mount with a fine line approximately half an inch (13 mm) from the inner border. With the white board I use a green line, and with the light cream a brown line.

Pen drawings can generally take a stronger treatment, being visually more powerful in black and white as opposed to the variety of greys found in pencil work. A deep green (olive) mount makes a strong match for the deep pen blacks and does not distract visually.

Either of these types of surrounds can be used with a 'clip mount', but the stronger pen-and-ink drawings with coloured mounts are more conducive to this method of presentation. The softer pencil drawings sometimes need a frame to contain the picture and to focus attention onto the subtle image.

Naturally, having chosen the mount for the picture, the frame you choose must match the mount. Again, over-elaborate frames can become a visual distraction – plain and simple frames are far more suitable for drawings.

For white mounts I would recommend a frame of plain aluminium or a plain lacquered wood (colour co-ordinated with the ink border line on the mount, of course). Either of these could be used for the olive-green mounts as well. Plain, pine or stained wood frames tend also to go well with the green mounts but are particularly suited to the cream board mounts.

Whilst mounting and framing will never make a bad picture look good, they can make an 'average' picture look very good and can make a good picture look spectacular. Should you consider exhibiting your work with a club or society, framing will become a major consideration and will, without doubt, help your work to sell.

A one-inch (2.5 cm) border drawn inside the edge of your paper is often useful. It will add additional visual impact by concentrating the viewer's attention onto the picture, which may not even require a mount if the border is kept clean enough whilst working.

Illustration Q
Victoria Pump, Woolpit, Suffolk: Pumps like this are to be found throughout Britain, and all provide a good focal point for a 'village scape'

This leads on to another point – 'fixing' pictures. Many aerosol cans of 'fixative' exist and may be bought in any art shop. They are, however, totally optional (and relatively expensive). Basically, the 'fixative' acts as does hair lacquer, forming a fine (translucent) film on top of the drawing, preventing it from smudging. This treatment is obviously important for charcoal or charcoal-type pencils as these cannot really be transported from the drawing site to your home without any smudging at all occurring, but this also effectively prevents your doing any more work on them once you do get them home. If your normal pencil drawings are to be transported or to be given to framers or even to printers or publishers for reproduction, 'fixing' is important (as they will invariably receive less courteous treatment in the hands of others). If, however, they are to be taken home and left in a safe place, or mounted and framed by yourself, fixing is not absolutely essential – really more of an expensive luxury.

13. Teaching Yourself

This book is not intended as a 'learn to draw in a day' publication. That is unrealistic. It is not, however, unrealistic to believe that you can learn much from a book – not everything, but by far enough to get started. This book is intended to be used as a stimulus in the first place, giving step-by-step stages for starting from the very beginning. Having made a start, it is then up to you to use the book for reference purposes when drawing/sketching 'on site' or for dipping into on occasion, as and when you require either a few tips or some inspiration.

Personal competence will come from practice wherever or whenever you can. A few lines sketched on the back of an envelope while waiting for a train, or on a notepad in the park during a lunchbreak, are the type of exercises that will help develop your ability to draw with accuracy and enjoyment. Time is not essential. A 'box' sketch can take only a few minutes to complete. A couple of these undertaken in a few spare minutes every week will pay great dividends. Do not try to go too far at once – this will only lead to disappointment. Just concentrate on the box construction of buildings at first, creating the basic yet accurate outline. This should take you only a minute or two. Then add a few windows, doors and chimneys, representing them in their simplest line form. Before long you will find you are completing these quick sketches very rapidly indeed and are waiting to move on to more of the demanding techniques of shading. Then return to the text of this book. Look again, and re-read, noting any specific points that you feel may apply to the scenes you have been sketching. Then go back to the buildings in the park that you sketched on the notebook, but this time take your sketchpad. Sketch with confidence (you know how to tackle this building by now) and spend ten to twenty minutes developing some tones and details in your picture by shading.

Alternatively, you could transfer your initial sketch onto a pad or paper in the warmth of your home. This is a quite acceptable practice and occurs frequently among amateur and professional artists alike. Transferring or re-drawing your work at

home can be a valuable exercise. However, the information that you take home with you does need to be reasonably accurate. In fact, there is no reason why your sketches should not be accompanied by a few written notes to remind you of the type of brick coursing (see Chapter 5), for example.

The great advantage of working this way is that you are not bound or restricted by time and weather conditions. You can leave your drawing and return to it as and when you feel inclined. The main disadvantage is that you will probably lose the spontaneity of the on-site drawing and possibly a little accuracy – but this is a reasonable sacrifice for an exhibition-quality piece of work. But in the early days of the development of your skills I would strongly advise drawing on site, for the following reason. It is relatively easy to 'copy' pictures, transferring a 2D image in two dimensions. The skill really lies in transferring three dimensions onto a 2D flat surface. This is why I place so much emphasis on awareness of perspective throughout this book. The experience you will gain through on-site drawing is absolutely invaluable.

However, should you wish to gain a little confidence before going out onto the streets to sketch a few 'box' buildings, why not try to work out the basic box structure of a few of the drawings in the book. I have included an appendix at the back of this book containing the basic box-construction techniques that I have used in my drawings, illustrating how a particular selection developed. This will do no harm if you have not attempted any serious sketching or drawing before. But once you have discovered how simple it really is, put the book

down and go outside to sample the real thing.

So what type of buildings should you start with? I advise you to start with a simple box building without too many additions. Avoid the more picturesque buildings at first. They probably seem attractive by virtue of the intricacy of detail and originality in construction. (Also stay clear of badly distorted old buildings. These are ideal for further development, but not at first.) A plain, seemingly uninteresting building will be a good starting-point. (In fact, your own home may well be your best possible starter drawing.)

As you gain confidence, the more you can afford to look towards the more attractive buildings. In fact, there is no reason why you should restrict yourself to drawing entire buildings. Why not just concentrate on any particular facet that you find interesting. Recording these can be of equal value and pleasure and often quicker when time is a major consideration to you. The skills involved are exactly the same – they just serve different purposes.

Wherever you travel – shopping trips on the bus, walking to the cinema, driving through new towns and villages, always be on the look-out for interesting buildings and architectural facets. Think 'buildings' wherever you go, and many districts will take on a very different meaning to you. Even if you do not have time to stop and sketch, just observe. Make some visual notes in the back of your mind, as you never know when a recall may be useful. The view of a pantiled roof seen from the top of a bus may well help you to understand the construction, which will ultimately aid you

when you come to draw a pantiled roof from the ground.

Many of the more picturesque buildings are frequently drawn by assorted artists during the summer months. As these are other people's homes, they deserve your consideration. Few people will object to your drawing their homes but do always respect their privacy. They may well have been upset by a less considerate person before and may take out their hostility on the next artist who sets up a stool opposite their house. If in doubt, there is no harm in asking.

As to style, there are several possibilities open to you, and these will be dictated partly by the medium you choose to use. Here a few ground rules may be worth noting.

Pen sketches can be quick and easy. The powerful contrast of black and white provides a strong instant image without the necessity of adding shading to counteract this strength with a level of subtlety. I suggest that this is the technique that you initially employ – straightforward line sketches using a fibre-tip pen (these are cheap and flow easily). Another suggestion here. Larger buildings (especially those with a lot of windows) and panoramic views are best suited to basic line sketches at first, as the level of factual detail will give your picture the interest required without your getting too involved with the complexity of shading in your early days. The only real disadvantage of sketching in pen is that all your lines are permanent. If you are starting from scratch in terms of experience, you will make mistakes. As you develop your level of confidence and skill, these will diminish, or

you will learn how to make the most of them with a little 'artistic interpretation', but initially this can be disheartening.

This is where pencil drawing scores points, though I would actively discourage anyone from relying heavily on a rubber to get them out of trouble. This often, in fact, inhibits 'free-style' sketching if you know that each line you make can be removed or changed if it is not quite right – the incentive to get it right first time diminishes. It is, nevertheless, a useful tool to have at hand during your first sketch or two.

Pencil sketches and drawings have much greater potential for subtlety than pen. As a range of soft grey tones can be achieved, a greater level of skill is required to handle this particular media successfully. Buildings surrounded by greenery or covered with ivy are particularly suited to pencil work, as are thatched cottages and those with softly painted walls. In fact, any building that involves a soft range of tones, or graduated shading, is more suited to pencil work in the first instance.

The level of finish to which you take any drawing depends entirely upon your own personal requirements and the time that you have available. If you are on holiday, for example, and have an entire day to devote to recording your surroundings, you may like to sketch every building in a village, capturing an overall impression or the atmosphere of it. Alternatively you may find one of two buildings that inspire you to spend a few hours on each. Basically, you will be sketching in your early days and progressing to detailed drawing at your own pace, and this will be determined by you alone.

So how do you make the first steps?

(Blank paper is intimidating at first, but this feeling soon turns to excitement as you experience the thrill of starting a drawing.)

It is essential to establish the outline of the foremost single building as your first step. If you are drawing a detached building, this is quite logical (if not a slightly absurd instruction), but in the frequent case of the building being part of a group, always establish the building that has caught your eye and which is to be the main point of interest in your composition. This is the one to be outlined first and should not be too far from the centre of your page.

If you are drawing the building at an angle, make your first line represent the edge of the building facing you, making sure that the height is correct for the scale of your drawing. Then quickly add the slightly converging lines that will form the two sides. If you are tackling a building 'face on', establish the height first by drawing in the top and bottom lines, then instantly cross-check this against the width and add the side-lines to form your basic box shape. Next the roof, checking that its incline is correct and that it starts and finishes in the right places. The third stage is to add the details such as windows, doorways, chimney-pots etc.

All of these facets are represented purely as lines, so that you have a plain line sketch. This may be sufficient for you, or you may wish to follow on from here to shade your drawing. The decision is yours. But these are the stages that should always be used to start a drawing.

14. Postscript

Whilst any art form is intensely personal and is an activity that you alone can control, this does not mean you must work in isolation. There may well come the time when you feel you need advice or help 'on site' at the very moment when the problem arises. This is where clubs and classes come in useful. Art classes can be found in all areas of the country and are run by many organizations and institutions.

Local Adult Education Colleges invariably offer a range of art evening classes, generally taught by practising art teachers. These are a very good starting-point but rarely offer any specific training, especially not in such a specialized area as drawing buildings. So it is perhaps more advisable to look for the colleges' day classes and weekend courses – perhaps a weekend painting and drawing in a local town, which will allow you much more scope to work in your own media and on your own subjects, picking the tutor's brain and skills only when you feel they are required. Many reputable artists run their own private courses (like the weekend courses I run in Suffolk) where you can simply go to work on whatever you wish and receive specialist advice and help on demand – or just enjoy drawing within an 'art' environment. The other important aspect of joining a class is that you will meet people who will have different skills, approaches and ideas. You may well learn more from these people than from the tutor!

This leads on to clubs and societies. Most towns have their own art club or society. Do not assume that these will be full of skilled and accomplished artists – they will be full of people just like you who simply want to meet people with similar interests and to share experiences, skills and inspiration. They also often organize guest speakers (another activity I often find myself involved in – and thoroughly enjoy), run drawing and painting visits to areas of special interest and mount annual exhibitions which will give you the opportunity to show your work if you wish.

So it's out onto the streets to draw. Whether you work in classes, with groups or alone,

you will find plenty of onlookers, hazards and distractions. But do not let them put you off. They are simply incidentals that go with the job of drawing objects that you have to go outside to find. Just enjoy it. Soak up the atmosphere and absorb the environment.

Have confidence in your work. Remember that you are only ever drawing an elaborate set of boxes – they may have complex façades and excessive ornaments but, fundamentally, they are a basic box shape underneath. Nothing more – nothing less.

Appendix

Box construction for Illustration C

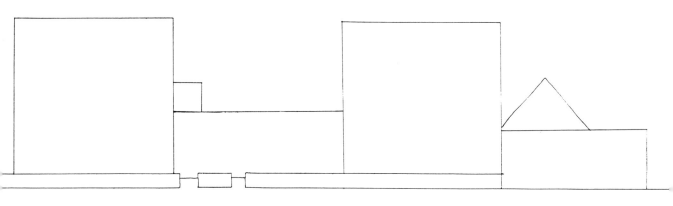

Stage A

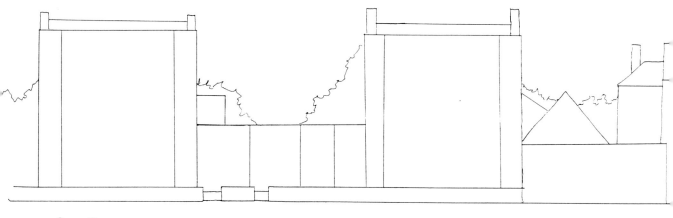

Stage B

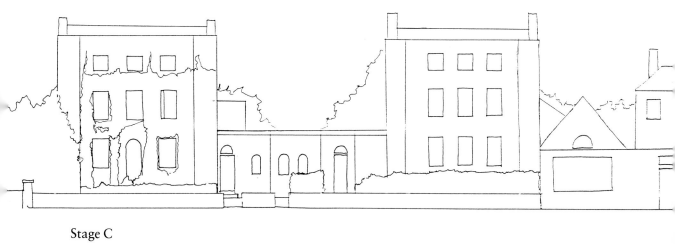

Stage C

Box construction for Illustration F

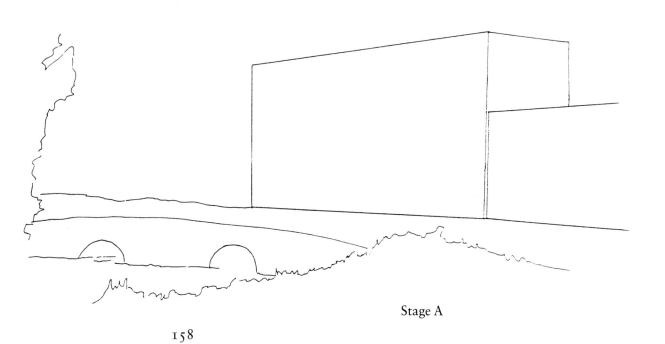

Stage A

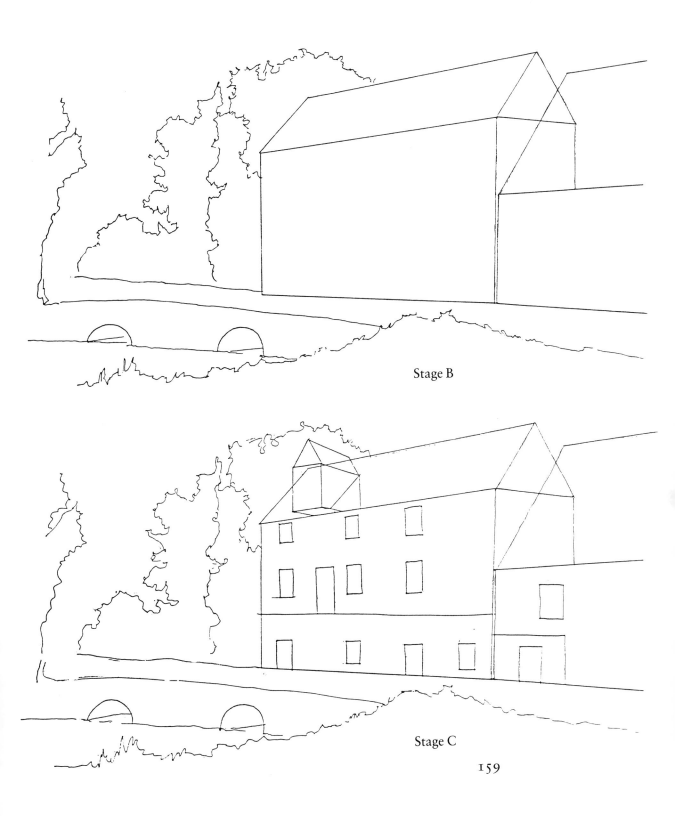

Stage B

Stage C

Box construction for Illustration G

Stage A

Stage B

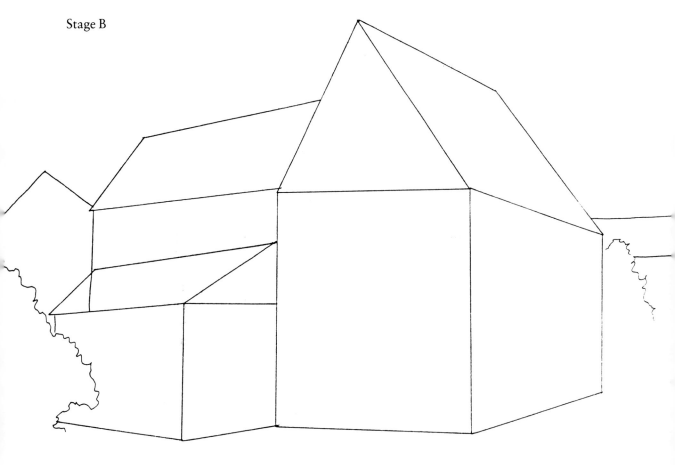

Stage C

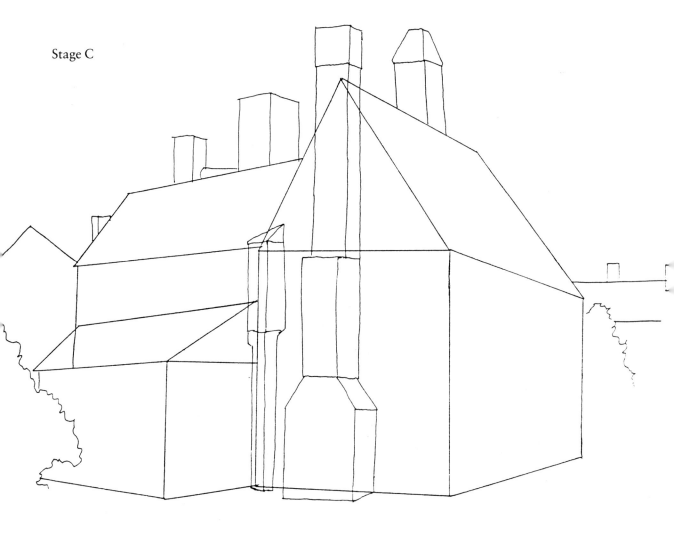

Stage D

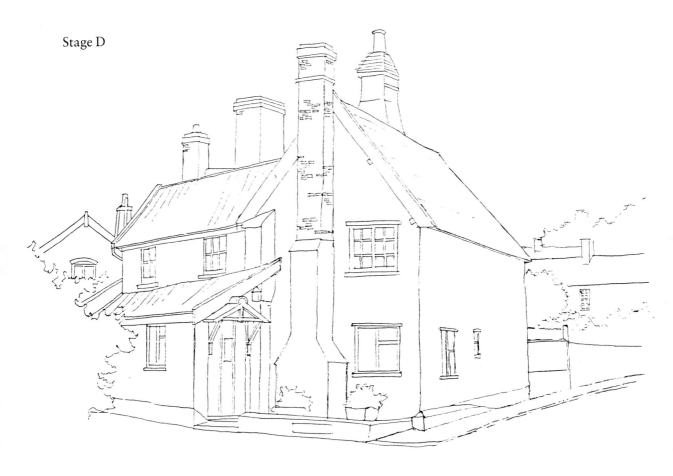

Box construction for Illustration J

Stage A

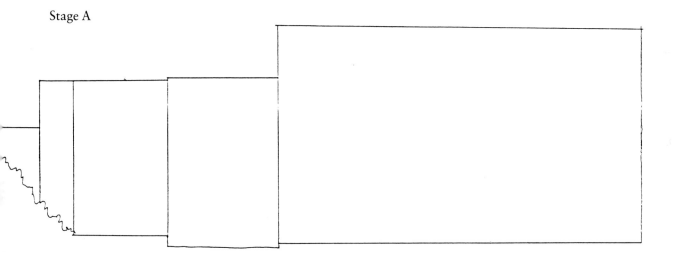

Stage B

Stage C

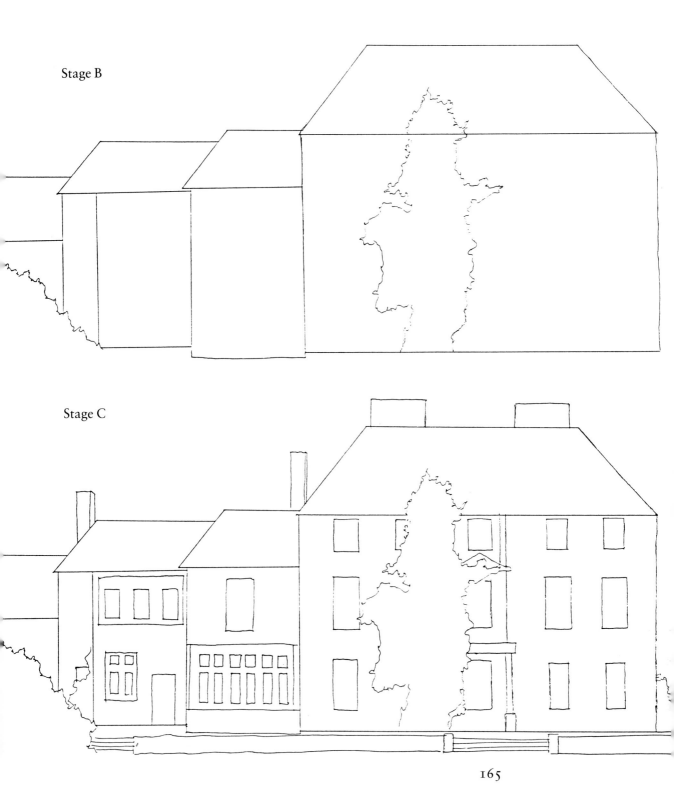

Stage D

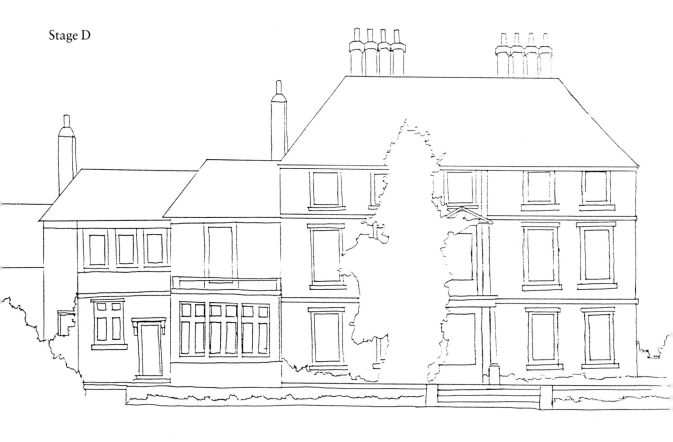

Box construction for Illustration L

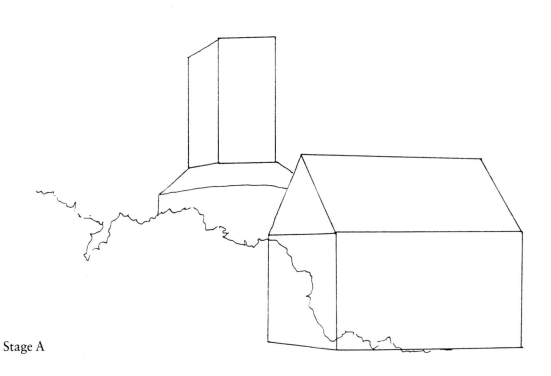

Stage A

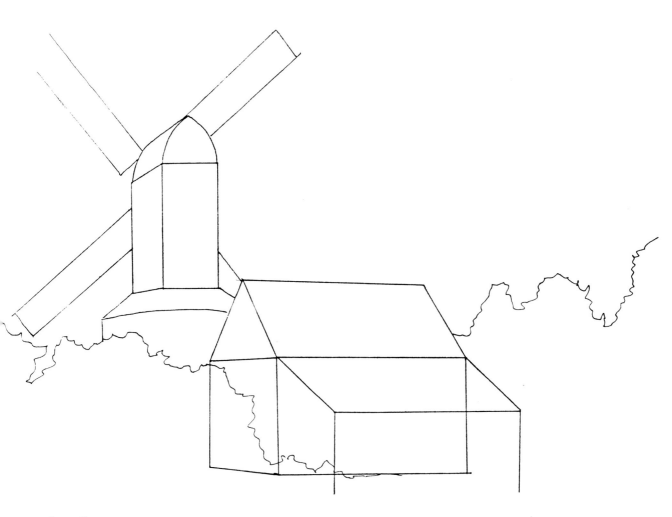

Stage B

168

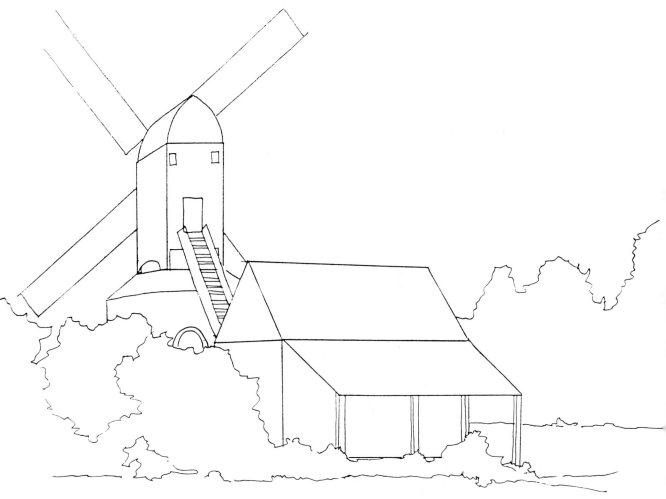

Stage C

Types of Gable

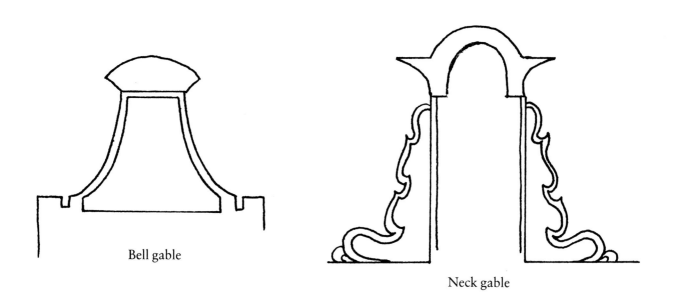

Bell gable

Neck gable

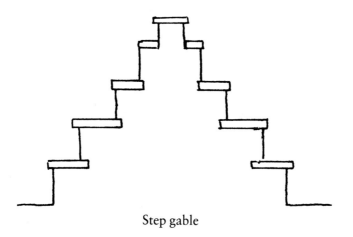

Step gable

Glossary of Architectural Terms

ASHLAR
Hewn blocks of masonry wrought to even faces, square edged and laid in horizontal courses with vertical joints.

BRICK NOGGING
A method of 'infilling' used to fill the spaces between timbers in timber-framed buildings. This is frequently, although not exclusively, found in a 'herringbone' pattern.

BUTTRESS
A mass of brickwork projecting from, or built against, a wall to give additional strength, counteracting the thrust from a roof.

COURSING
A continuous layer of bricks in a wall.

DORMER
A type of window placed vertically in a sloping roof and having a roof of its own. This was usually a sleeping area; hence its name.

EAVES
The lower part of a roof projecting beyond the face of a wall.

FLYING BUTTRESS
An arch, or half arch, transmitting the thrust of a roof from the upper part of a wall to an outer support or buttress.

GABLE
The triangular upper section of a wall at the end of a pitched roof.

GEORGIAN
Classical style of building, chiefly small and domestic.

GOTHIC
Name generally given to the 'pointed' style of medieval architecture, most prevalent between the thirteenth and fifteenth centuries.

HERRINGBONE
Stone or brickwork set in diagonal lines with alternate courses being laid in opposite directions, creating a zigzag pattern across the wall.

JETTYING
Generally found in timber-framed buildings. This involves the projection of an upper storey beyond the storey below by means of beams and

joists. Buildings can be jettied on more than one side and on more than one level.

LANCET WINDOW
A slender pointed arched window, popular with thirteenth-century builders. Characteristic of early English architecture.

NORMAN
A style of eleventh- and twelfth-century curved windows and doors.

PALLADIAN
A dominant force in British architecture, being the revival of Roman symmetry and harmonic proportions.

PANTILES
Roofing tiles with curved S-shaped sections.

PARAPET
A low wall placed to protect any spot where there is a sudden drop – frequently found on the edge of flat roofs.

PERPENDICULAR
A name given to a style of architecture whose chief features are the stress of straight verticals and horizontals, large windows and window tracery with little fantasy or inventiveness. Popular between 1350 and 1580.

PINNACLE
A small turret-like termination, crowning spires, buttresses etc. Usually of pyramidal or conical shape.

PORCH
The covered entrance to a building.

RENAISSANCE
A term meaning 're-birth' but referring to the late fifteenth-century return to ancient Roman standards and influences.

RUBBLE
Rough building stones or flints, not laid in regular courses.

SASH WINDOWS
A window with sliding glazed frames running in vertical grooves.

SPIRE
A tall, pyramidal, polygonal or occasionally conical structure rising from a tower or roof. Generally made of stone or timber, frequently placed onto a square tower with an immediate parapet.

STUCCO
A form of plasterwork, generally smooth.

TERRACE
A row of attached houses built as one unit.

THATCH
A roof-covering made of straw and reeds.

THRUST
The outward force of a wall, arch or vault.

TRACERY
The ornamental intersecting stonework in the upper part of a window used decoratively. It also serves to hold the glass in Gothic windows.

WATTLE-AND-DAUB
A method of wall construction consisting of thin branches roughly plastered over with mud or clay. This system of infilling was frequently used to fill between the timbers of timber-framed buildings.

WEATHERBOARDING
Overlapping horizontal boards or planks of wood covering timber-framed walls. The upper edge is often thinner, allowing a clinker-style method of attachment.

Further Reading

Addy, S. O., *The Evolution of the English House* (Allen & Unwin, 1898; revised 1933)

Barley, M. W., *The English Farmhouse and Cottage* (Routledge & Kegan Paul, 1961)

Batsford, H. and Fry, C., *The English Cottage* (Batsford, 1938)

Brown, R. J., *The English Country Cottage* (Robert Hale, 1979)

Brunskill, R. W., *Illustrated Handbook of Vernacular Architecture* (Faber & Faber, 1970)

Cave, Lyndon F., *The Smaller English House – Its History and Development* (Robert Hale, 1981)

Cook, Olive and Smith, Edwin, *English Cottages and Farmhouses* (Thames & Hudson, 1954)

Evans, Ray, *Drawing and Painting Buildings* (Collins, 1983)

Fletcher, Banister, *A History of Architecture* (Batsford, 1896)

Innocent, C. F., *The Development of English Building Construction* (Cambridge University Press, 1916)

Mercer, Eric, *English Vernacular Houses* (HMSO, 1975)

Sisson, Marshall, *Country Cottages* (Methuen, 1949)

Warren, C. Henry, *English Cottages and Farmhouses* (Collins, 1948)

West, Trudy, *The Timber-frame House in England* (David & Charles, 1971)

Woodforde, John, *The Truth about Cottages* (Routledge & Kegan Paul, 1979)

Index